MW00534093

TESLA: *All My Dreams Are True* jolts and flows between the extraordinary life of the inventor Nikola Tesla, the making of a feature film about him by the celebrated director Michael Almereyda, and episodes from the filmmaker's own restless, quixotic career. In these pages, we encounter Tesla's colleagues and friends intermingling with Almereyda's collaborators and influences: Thomas Edison and David Lynch, Mark Twain and Sam Shepard, Sarah Bernhardt and Ethan Hawke, J. P. Morgan and Orson Welles. A rich array of illustrations—including film stills, drawings and comic-book art—enhance the sense of time travel and parallel histories, as we read of a scheme to transmit wireless energy through the earth, of the electrocution of an elephant, of fortunes made and surrendered, and of the obsessions that propel a scientist seeking to transform the world and a director seeking to make a movie.

Advance Praise for **TESLA: All My Dreams Are True**

"A beautifully written, compelling and un-categorizable book . . . [that] surprised, delighted, and enriched me."

—**Lynne Tillman**, author of *What Would Lynne Tillman Do?* and *Men and Apparitions*

"Michael Almereyda shows the route he took in making his extraordinary sort-of-biopic about Nikola Tesla. The dazzling result is part memoir, part biography, part filmmaking diary, a meditation on what it means not just to make a movie, but to will it into being over decades."

—**Stephanie Zacharek**, film critic, *Time*

"Candid and poignant, Almereyda's account of Tesla and himself is illuminating, ironic and intimate. Acrobatic without pretense or strain. A joy to read. (A book to keep.)"

—**Hampton Fancher**, screenwriter of *Blade Runner* and *Blade Runner 2049*

"This superb, wonderfully illustrated book is much more than a companion to *Tesla* . . . It's a joy to spend time with an artist for whom filmmaking and criticism are so richly intertwined."

—**Andrew Chan**, critic and web editor at the Criterion Collection

"A book of reflections and refractions that, taken together, encompass the inventor, the filmmaker, and the film in one remarkable multi-faceted work."

—**Carter Burwell**, composer for *The Big Lebowski*, *Adaptation*, and *Carol*

"Fascinating . . . compelling . . . an oblique memoir and a virtual manual on all the calculations that scriptwriting entails."

—**Jonathan Rosenbaum**, author of *Discovering Orson Welles* and *Cinematic Encounters*

TESLA

ALL MY DREAMS ARE TRUE

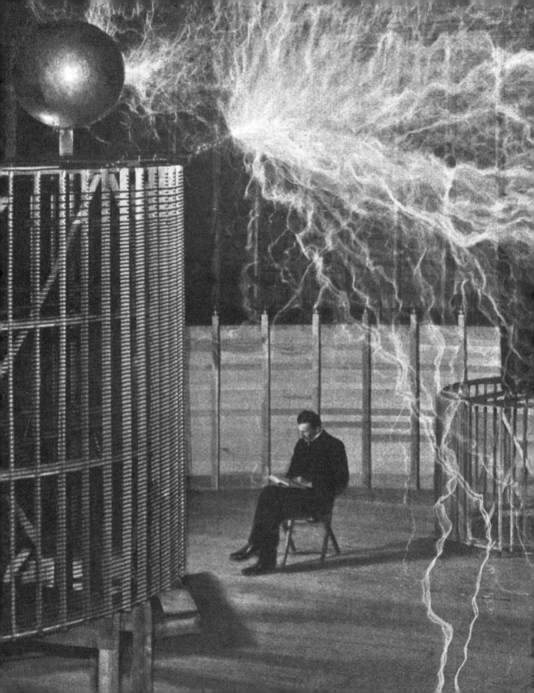

TESLA

ALL MY DREAMS ARE TRUE

MICHAEL ALMEREYDA

OR Books

New York · London

All rights information: rights@orbooks.com
Visit our website at www.orbooks.com

First printing 2022

Published by OR Books, New York and London

© 2022 Michael Almereyda

All rights reserved. No part of this book may be reproduced or transmitted in any form or by any means, electronic or mechanical, including photocopy, recording, or any information storage retrieval system, without permission in writing from the publisher, except brief passages for review purposes.

Every reasonable effort has been made to contact the copyright holders of archival photographic materials collected in this book. Questions may be directed to rights@orbooks.com.

Library of Congress Cataloging-in-Publication Data: A catalog record for this book is available from the Library of Congress. A catalog record for this book is available from the British Library.

Book design by Eliot Larson.

paperback ISBN 978-1-68219-282-5 • ebook ISBN 978-1-68219-286-3

Cover and Frontispiece (detail): Nikola Tesla in his Colorado Springs experimental station, a photograph made from multiple exposures, by Dickenson V. Alley, 1899.

For

Ethan Hawke

Kyle MacLachlan

Karl Geary

Lois Smith

Jim Robison

Susan Kismaric

and

Jessica Holburn

without whom . . .

The Brain—is wider than the Sky—
For—put them side by side—
The one the other will contain
With ease—and You—beside—
—Emily Dickinson

 As the film falls apart, gather up your mistakes
and treasure them.
—Derek Jarman on *Wittgenstein* (1993)

CONTENTS

INTRODUCTION:
NASTY MICROBES

What drew me to Nikola Tesla when I was a teenager, more than forty years ago, is not quite the same as what drew me to make a movie about him in 2019, and the coordinates shifted altogether during 2020, a shared hallucination of a year, when this book was written. Time, it's been commonly agreed, feels different: muffled, staggered, destabilized, alternately freezing and skipping forward, as we've found ourselves jostled between quarantine and protest, detachment, division, and some semblance of solidarity.

I haven't been able to resist thinking about how I'd make my film over again, if I could start fresh or simply apply a new coat of paint. I'd pretty surely pay more heed to Tesla's germaphobia. In *My Inventions*, the autobiography serialized in *Electrical Experimenter* magazine in 1919, written when Tesla was sixty-two (startlingly, not much older than I am now), he describes his experience with cholera, when an epidemic descended upon his home town of Gospic, in what's now Croatia. He was eighteen, returning from school:

Nikola Tesla in January, 1894. "First photograph ever taken by phosphorescent light." From *The Century Magazine* (April 1895).

It is incredible how absolutely ignorant people were as to the causes of this scourge . . . They thought that the deadly agents were transmitted thru the air and filled it with pungent odors and smoke. In the meantime they drank infested water and died in heaps. I contracted the dreadful disease on the very day of my arrival and although surviving the crisis I was confined to bed for 9 months with scarcely any ability to move. My energy was completely exhausted and for the second time I found myself at Death's door. In one of the sinking spells which was thought to be the last, my father rushed into the room. I still see his pallid face as he tried to cheer me in tones belying his assurance. "Perhaps," I said, "I may get well if you will let me study engineering."

That is an origin story, of a kind, building on Tesla's first visit "at Death's door," just a few years earlier, when he was fifteen, bedridden with malaria. (The malaria, transmitted by mosquitoes, had lingered, leaving him particularly vulnerable to cholera.) Images of lethal microorganisms chased Tesla throughout his life. In Paris, shortly before leaving for the US in 1884, with an introduction to Thomas Edison in hand, he worked with a scientist studying the properties of drinking water. As recounted in a letter written sixteen years later to his friend Robert Underwood Johnson, the invitation to look through a microscope perpetually heightened Tesla's horror of germs:

If you would watch only for a few minutes the horrible creatures, hairy and ugly beyond anything you can conceive, tearing each other up with the juices diffusing throughout the water—you would never again drink a drop of unboiled or unsterilized water.

I wasn't interested in making a matter-of-fact biopic showing young Tesla moving through his travails and triumphs, but the inventor's lifelong fear of contamination is acknowledged throughout the film. His memory of the cholera epidemic surfaces in an important patch of dialogue, with a bitter nod to the superstition that guided his countrymen to mismanage the crisis. He's shown wiping glasses and cups before drinking, avoiding handshakes, wearing gloves, and, while seated in a restaurant, working through a stack of cloth napkins to clean utensils and plates. But I now wonder if we could have underlined this a bit more, given how far and deep Tesla's fear reached, and how the present moment is saturated with a commensurate dread.

In the fifth installment of *My Inventions*, after praising the departed J. P. Morgan, an investor who had, in reality, left him high and dry, inspiring a string of private pleas and complaints, Tesla offers a curse to unspecified enemies. "I am unwilling to accord to some small-minded and jealous individuals the satisfaction of having thwarted my efforts. These men are to me nothing more than microbes of a nasty disease." For Tesla, no insult could be loaded with more contempt—nothing's worse than "microbes of a nasty disease."

But his next lines swerve to self-justification and prophesy, a tone that characterizes Tesla's written pronouncements, inviting a martyrdom that many of his fans continue to embrace. My movie carries him up to 1901, drawing the curtain with the failure of a grand scheme for the worldwide transmission of wireless energy, involving the construction of an enormous tower in Wardenclyffe, Long Island. This was the enterprise J. P. Morgan had withdrawn from after giving Tesla the equivalent of $4 million in today's

money. With the dismantling of the Wardenclyffe tower, Tesla was, indeed, thwarted and finished. But he was hardly able to admit this to the readers of *Electrical Experimenter*, or to face his own role in the defeat. "My project was retarded by laws of nature," he concludes. "The world was not prepared for it. It was too far ahead of time. But the same laws will prevail in the end and make it a triumphal success."

Tesla lived another twenty-four years after writing these words, long enough to see the future consumed by the Second World War. By then, he had suffered more setbacks, and became increasingly reclusive and unhinged, the predictor of doomsday scenarios, the promoter of an unrealized death beam. I had included scenes of the wraithlike, elderly Tesla in my original script: a gaunt old man in a barren suite in the Hotel New Yorker, where he kept pigeons while instructing the staff to maintain a three-foot distance from him at all times. Budget constraints convinced me to cut this material, but the image of a skeletal, self-isolating germaphobe continues to haunt me.

I chose to focus on a different Tesla, the inventor of technological breakthroughs that still define the way we generate and receive light and power. A proud, recessive outsider motivated by an idealism that was seldom practical. I wanted to honor him, a scientist of mind-bending resourcefulness and prescience who was also hapless with money and even more hapless in making and keeping personal connections. I saw the movie as a story about love and money, even or especially if the brilliant protagonist had little talent for managing their flow.

Tesla, age thirty-five, in England, 1892, photographed by Herbert Rose Barraud.

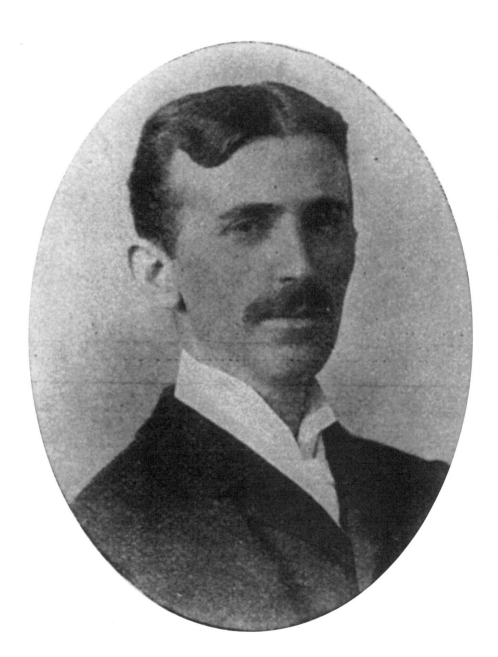

Late in 2019, when Colin Robinson—the R in OR Books—invited me to gather my thoughts and set them loose in these pages, it felt like a fair opportunity to collect my best guesses about Tesla's history and legacy, to sort through evolving clues, questions and convictions, despite and including my stop-start efforts to make a movie about him. The following chapters, like the movie itself, constitute an exercise in time travel, a freeform collage, an incidental, inevitable self-portrait. But I've tried to think beyond my private horizon, and beyond the film, sifting through the residue of what I merely thought I was doing.

Tesla had once been a very public figure, dashing, resourceful, self-possessed and even, for a sustained interval, famous and wealthy. As a lecturer he could draw a crowd of four thousand people, capping dense scientific discourse with a rhetorical flourish: "We are whirling through space with an inconceivable speed. All around us everything is spinning, everything is moving, everywhere is energy." It's bracing to reread these words in a time caught between suspension and turmoil, and to recognize in the accelerating contradictions that energy and change, action and optimism, might still reactivate our engagement with the future.

New York, January 2021

Tesla caricatured by Marius de Zayas, New York, circa 1908.

A TESLA TIMELINE

July 10, 1856 Born in a small mountainside village, Lika, Smiljan, part of the Austro-Hungarian Empire, now Croatia. Nikola Tesla is the fourth of five children. His father is an orthodox Serbian priest, his mother an illiterate housekeeper who invented domestic devices for cooking and weaving.

1863 Tesla's older brother Dane dies after being thrown by a horse. Shortly after, the family moves from the country to Gospic, Smiljan.

1875 Tesla studies mechanical and electrical engineering at the Polytechnic school in Graz, Austria.

1880 Attends the Karl-Ferdinand University in Prague; studies philosophy but never officially enrolls.

1881 Takes a job with the Hungarian Central Telegraph Office in Budapest, where he befriends Anital (Anthony) Szigeti.

1882 In Budapest, walking with Szigeti in a park at sunset, Tesla arrives at the idea of a motor generating alternating current by means of a rotating magnetic field. Tesla and Szigeti move to Paris in April, working for the Continental Edison Company. Thomas Edison's business manager supplies Tesla with a letter of recommendation to Edison.

1884 Tesla comes to New York City aboard the *SS City of Richmond* and goes to work at the Edison Machine Works. He fails to interest Edison in his alternating current motor. Following a dispute about money, he quits after six months.

1885 Tesla is swindled by investors in his newly formed lighting company. Forced to work as a manual laborer, he digs ditches for the Western Union Company for a full year.

1887 Two intrepid businessmen invest in Tesla's AC motor, furnishing him with a salary and a lab. They pay to bring Szigeti to New York to facilitate the development of practical prototypes.

1888 George Westinghouse purchases Tesla's AC patents—a full system for transmitting electrical and motive power. Tesla spends a year in Pittsburgh, home base for Westinghouse's factories, presiding over the commercial application of his designs.

1890 Struggling to retain control of his company, Westinghouse persuades Tesla to tear up his contract, sacrificing future royalty payments amounting to millions of dollars.

1891 Tesla demonstrates high-frequency induction and wireless lighting at Columbia University. He is sworn in as a US citizen on July 30.

1892 Tesla undertakes a European tour to promote his polyphase AC system. Arrives in Gospic in time to witness his mother's death, April 4.

1893 Sponsored by Westinghouse, Tesla displays electrical marvels to great acclaim at the Chicago World's Fair.

1894 Publication of Tesla's *Inventions, Researches, and Writings*. Tesla becomes a regular guest at the Lexington Avenue home of *Century Magazine* editor Robert Underwood Johnson and his wife Katharine; other dinner companions include Rudyard Kipling, John Muir, Mark Twain, and Anne Morgan. Columbia University grants Tesla an honorary degree, the first of his fifteen honorary doctorates.

May 17, 1895 Tesla's lab on South Fifth Avenue is destroyed by fire.

November 16, 1896 The Niagara Falls Power Plant comes online, triumphantly transmitting energy and light by means of Tesla's designs.

Tesla lecturing before the French Physical Society and the International Society of Electricians, 1892.

May-December, 1899 Tesla moves to Colorado Springs, CO, builds a unique experimental station and undertakes research in wireless telegraphy. In July he receives a radio signal he believes originated on Mars.

1901 With a significant investment from J. P. Morgan, Tesla begins construction of a wireless tower on the Wardenclyffe property in Shoreham, Long Island. But the project is soon undermined by reports of Marconi's transmission of a wireless signal across the Atlantic.

1916 Deep in debt, with his Wardenclyffe project still unrealized and incomplete, Tesla declares bankruptcy.

1917 The Wardenclyffe tower is dismantled and sold for scrap.

1917-26 After being evicted from the Waldorf-Astoria Hotel, Tesla lives in Chicago, Boston, Milwaukee, and Philadelphia, consulting for various manufacturing companies. He resettles in New York City, where he resides for the rest of his life.

1934 On his seventy-eighth birthday, Tesla announces the discovery of his death beam, but is reticent with details.

July 7, 1943 Tesla dies, destitute and alone, in the Hotel New Yorker.

1 LOVE INTEREST

Tesla had no known romantic relationships. I grew to assume this accounted for Hollywood's inability to launch a Tesla biopic. The model for successful movies about tormented scientific geniuses requires the attachment of a strong, beautiful, abiding wife. The science then becomes the MacGuffin, the abstract thing the protagonist is pursuing —the smoky blackboard clotted with equations; fireworks going off in the genius's eye. Two conspicuous Oscar-blessed entries in this genre are *A Beautiful Mind* (2001) and *The Theory of Everything* (2014), wherein Jennifer Connelly and Felicity Jones obliterate the audience's need to consider or understand even a rudimentary spoonful of physics; the true focus of these films is the emotional heat generated by the husband-and-wife relationship. Love humanizes the genius, and makes

Eve Hewson as Anne Morgan in *Tesla* (2020).

him (yes, it's always a *him*) tolerable. Even Cronenberg's *The Fly* (1986) and Aronofsky's *Pi* (1998), for me the best fictive portraits of science nerds with runaway hyperactive minds, require a woman in the picture to give emotional valence to the hero's delirious descent. In any sensible movie, depriving a physicist of female companionship is like remaking *King Kong* without the requisite blonde starlet. Why, and how, would you even attempt it?

But you can't give Tesla a love interest without reaching into a void and pulling out a fantasy, an invented relationship based, at best, on implications and rumors. The most cringe-worthy aspect of my first draft, completed in 1981, involved the engineering of a love triangle between Tesla, his business manager George Scherff and Scherff's wife, whom I called Maura, in the absence of any other available information.

When I reappraised my screenplay decades later, the made-up drama embarrassed me. I cut Scherff from the story, and his fabulous wife, and, on the evidence at hand, revising the script, I left Tesla alone, a steadfast celibate germaphobe, chivalrous around women, even flirtatious, but ultimately aloof, unavailable, untouchable. "An inventor has so intense a nature," he asserted in an oft-quoted 1897 newspaper interview, "with so much in it of wild, passionate quality, that in giving himself to a woman he might love, he would give everything and so take everything from his chosen field . . . It is a pity too, for sometimes we feel so lonely."

I told Ethan Hawke I assumed Tesla was gay. There's no hard proof, but sufficient and convincing clues have been inventoried in recent

books, enough to both persuade me of Tesla's sexual preference and to fill me with sympathy for his situation, the fact that he felt compelled to muffle or strangle that inadmissible part of himself. Tesla's persona as a solitary genius, developed and refined early in his life, involved an all-consuming commitment to work, even if desire, conscious or otherwise, could be glimpsed around the edges of documented actions and thoughts.

The playing out of desire shapes a plot, whether central or sub-terranean, factoring in our deepest personal histories, so of course the subject takes center stage in the stories we care about most, in actuality and in the looking glass of fiction. Reapproaching Tesla, I turned, with some inevitability, to two of his distinguished and repressed contemporaries, John Singer Sargent (born in 1856, the same year as Tesla) and Henry James (born thirteen years earlier), both American expatriates who lived cloaked or closeted lives in Europe, retaining their status as respectable bachelors at evident cost to themselves. And of course their work mirrored their emotional conflicts, sharpened and deepened by insight and subterfuge.

The richness of Sargent's paintings and watercolors, his dramatic use of light and shadow, provided an obvious inspiration for the film. As shimmering records of a specific social scene, celebrating the poise and beauty of his subjects, Sargent's best images are indispensably attuned to the glamor of the Gilded Age even as they also describe elements of darkness and disquiet. James's influence on the film was equally powerful, if more oblique. Of all his stories of misdirected desire and

unrequited love, "The Beast in the Jungle" had the most relevance: the story of a man fencing in the potential wildness of his emotional life, resisting the temptation, cancelling the need, to commit himself to intimacy and love, even as a supremely loyal and patient woman attends to him throughout a life he realizes—too late—has been wasted. I felt the tale speaks to Tesla's isolation, his loneliness, and I invited the spirit of Henry James to hover over the film by smuggling in Wojciech Kilar's music for Jane Campion's *The Portrait of a Lady* (1996), one of the best James adaptations on film and one of my favorite movies about love, misguided or otherwise.

As Jean Strouse has written (in *Alice James, A Biography*) women in James's work "are far more capable of seeing into life than his men are . . . In their freedom from the material and professional constraints of the masculine world, they represented the dilemma of choice, imagination and knowledge that James saw as the essence of human experience." Tesla may have possessed superhuman powers for penetrating the mysteries of physics and electrical engineering, but he was blind when it came to sorting through his feelings, making human connections, "seeing into life." Ethan and I had to keep asking: What's really at stake in this story—other than the fate of potentially transcendent technological projects? What are the emotional costs? "The dilemma of choice, imagination and knowledge"—this is the arena I wanted to enter, applying a woman's voice to track the yearning at the heart of Tesla's story.

John Singer Sargent, *Peter Harrison Asleep* (detail), 1905.

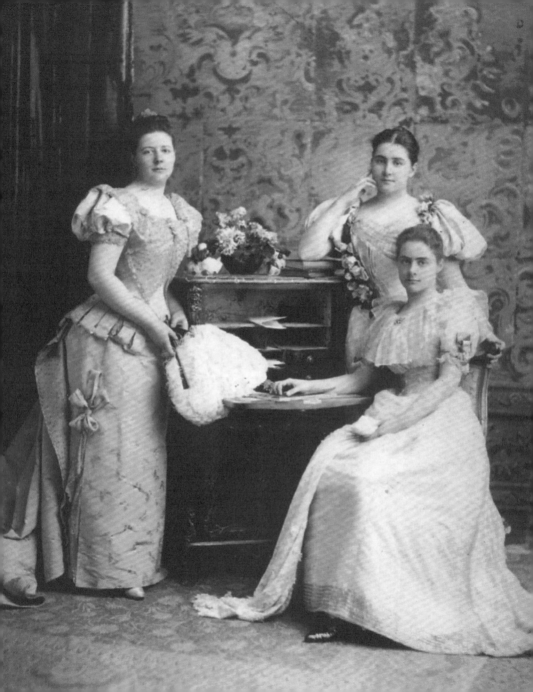

2 THE CAT TALKED

Ethan committed to playing Tesla on the strength of an intermediate draft—a screenplay awkwardly balancing new and old ideas—and his notes were crucial for shaping the approach that eventually carried the day.

He agreed it would be exciting to see Tesla sharing the movie with his contemporaries, giving more time and attention to Edison, Sarah Bernhardt, and J. P. Morgan, with Morgan's willful young daughter, Anne, functioning as a narrator who steps out of character and the flow of time to deliver facts and opinions that weren't necessarily within her reach. This was an advance from the first draft, which had no narration, but the in-between script had, I shudder to remember, *three* different narrators. Working from a 2017 visit to Edison's birthplace in Milan, Ohio, I gave the first stretch of narration to a contemporary tour guide at the Edison Museum, a beleaguered, fast-talking woman wearing a

Anne Morgan (on the right) with her older sisters, Louisa and Juliet, circa 1900.

corseted costume harking back to the 1880s. She provides pedantic opinions about the Tesla–Edison rivalry. Then, midway through the movie, the narrative baton was transferred to another guardian of history, an up-to-the-moment Serbian woman—I was determined to get more women into this male-dominated chronicle—a tour guide in Belgrade's Tesla Museum, conveying aggressive pride in the virtues and triumphs of her legendary countryman. Lastly and, I imagined, most poignantly, the actress playing Anne Morgan takes charge, reporting on Tesla's difficulties and, in the final scene, his death, as a hotel maid snaps a sheet over the inventor's corpse and FBI agents crack his private safe.

I was aiming for a flexible and multifaceted structure, and a degree of playfulness. I cited *Drunk History* more than once, though I was mainly fixated on the inspired inaugural episode of that long-running joke, initiated by Derek Waters and Jeremy Konner in 2007, a series of short films giving truly inebriated narrators an opportunity to stammer, grope and vomit their way through unchallenged versions of historic events, intercut with suitably cheesy reenactments. I don't know how many times I lapped up the five and a half minutes of *Drunk History Vol. 1*, wherein Michael Cera's Alexander Hamilton tearfully bids farewell to his family via flip-phone and the narrator, Mark Gagliardi, manages his slow final words while plastered facedown on his couch. The results were less stunning in later episodes, particularly when the Drunk Historians worked their way up to Tesla vs. Edison, with John C. Reilly aggressively miscast as Tesla, and Crispin Glover playing Edison. All the same, over time, rummaging through books,

archived newspapers and the internet, I developed the dim, dizzy conviction that *all history is drunk history*. How else to consider the mix of guesswork and gossip, the solemn reports based on self-serving testimony, inventive memories, faded photographs, books without footnotes, comic-book adaptations of these books, the make-believe of winners crowding out competing vagaries from losers—all the circumstances and sources that can muddle the telling of even recent events at least as wonderfully as sheer dumb drunkenness?

Ethan soberly helped me see that the story needed a single narrator whose voice and viewpoint leave the emotional focus unblurred while engaging more directly with our notably difficult protagonist. And so Anne Morgan elbowed out the two tour guides, expanding her expository role, framing the full story while bobbing up within it, an intrigued, self-possessed though slightly neurotic and ultimately vulnerable young woman who challenges Tesla's inwardness. As I imagined her, no other character had such a stake in the matter, was paying such close attention to Tesla, and could empathically tell us what she knew.

But here, it's necessary to admit, there's not much confirmable documentary truth in my portrait of Miss Morgan. The record of her early life is so scant, I was compelled to make things up. And in so doing I looped back to my original sin: I inserted an element of fantasy to bring out facets of the story I considered most moving and meaningful. That said, the more I learned about the real Anne Morgan, the more I imagined her ghost wouldn't mind the presumption.

We know that Anne Tracy Morgan, the youngest and most unconventional of the financier's four children, was highly cultured, home-schooled, well traveled. As a young girl she accompanied her father on journeys to Europe and his first trip to Egypt, where they were given private viewings of the Great Pyramid and the Sphinx. She was spirited and independent enough to announce to her father that when she grew up she would be "something better than a rich fool." She did not rush into marriage. Her name is dropped in almost every Tesla biography but fleetingly, sometimes wistfully, as a dinner companion circulating in the salon of Robert Underwood Johnson and his wife Katharine, though Tesla first met Anne, age twenty-seven, in November 1900, when he was one of twenty-four hundred guests attending the wedding reception for her oldest sister, Louisa, and Mr. Herbert Satterlee. (I had no desire to recreate this event, especially on a small budget.)

Claiming questionable artistic license, I elasticized Anne's age to insert her earlier in the Tesla timeline. It's the one truly extravagant stretch in a movie that takes pains to be factual. Although she would have been fifteen at the time, I introduced Anne to our hero in the winter of 1888, when Cornell professor William Anthony reviewed Tesla's AC induction motor, preceding the inventor's breakout debut before the American Institute of Electrical Engineers. Anne delivers a short monologue initially written for Professor Anthony's niece (one of the few purely invented characters in the script); it was an aside contrived to catch Tesla's attention while acknowledging the unscientific, animistic spiritual value some of us might sentimentally attribute to electric

Anne Morgan dressed as Queen Elizabeth, 1907.

light. The idea was to add mystery and emotion to the demonstration of Tesla's humming and whirring motor, and to hint at an erotic undercurrent.

In reality, Anne's interest in Tesla wasn't strong enough, or sufficiently reciprocated, to kindle anything resembling romance, though they continued to exchange letters over the years. In most of the surviving photographs, in middle age and beyond, Anne appears as tall, distinguished, and as invincibly humorless as Margaret Dumont, eternal foil of the Marx Brothers. Nevertheless, these pictures hint at her boldness. In a series of studio portraits commemorating appearances at Gilded Age galas, she's elaborately costumed as Pocahantas, Queen Elizabeth, and Marquis de Lafayette. Around 1910, with gathering confidence and clarity, she carved a path for herself that was distinctly adventurous, proto-feminist, and heroic. She became an activist for women's rights, standing in picket lines, using her wealth and social position to support striking female "shirtwaist workers" in New York's garment district. In 1912, she co-created the Society for the Prevention of Useless Giving, a serious and practical organization urging the reallotment of money spent on Christmas-related materialism, a campaign designed to help working women. (Theodore Roosevelt, three years out of work as president, was the first male to join its ranks.)

A primary element of her philanthropy involved the conviction that social work requires direct engagement, education, community service. World War I opened another level of commitment, prompting her to channel a great deal of money and energy to relief efforts in France,

where she was sharing a villa in Versailles with literary agent Bessie Marbury and actress/interior designer Elsie de Wolfe, a lesbian power couple comfortably open about sharing their lives. The three became known as the Versailles Triumvirate.

Among her later accomplishments is a celebrity cookbook published in 1940, *Spécialitiés de la Maison*, assembled to aid her charity, the American Friends of France. The contents include recipes provided by Charlie Chaplin, Katharine Hepburn, and Laurence Olivier, as well as contributions by people named Rockefeller, Vanderbilt, and Astor. Miss Morgan's personal offering is for "Champagne Punch." She may have been an iconoclast, in quiet and brave ways, but she didn't rattle the social order she was born into.

Eve Hewson impressed me when I first saw her, in early 2014, on the set of Steven Soderbergh's *The Knick*, in which she plays a sharp, vulnerable nurse witnessing the drug-fueled descent of Clive Owen's messianic doctor. Watching from a corner during the shooting of an early episode, I caught a terse bit of direction from Soderbergh, addressed to Mr. Owen when Eve, standing upright, aims a few words of defiant advice to the doctor, crumpled on the floor. "The cat talked," Steven said. Five years later, I was lucky to have Steven alert Eve to the script's existence—agents routinely deflect offers from low-budget films—and doubly lucky when Eve sparked to the role. She recognized a screwball element in Anne's scenes with Tesla—the suggestive circling motions of their conversations, the echoes of movies that pair knowing, madcap heiresses with distracted men living in their heads. And "of

course she has daddy issues," Eve noted. We barely had to touch on the fact that her father, Bono, happens to be at least as famous as J. Pierpont Morgan in his heyday. Soderbergh's cat analogy infiltrated the script before I'd approached Eve, fusing with the opening narration, which is lifted from Tesla's slim autobiographical children's book written in 1939, *A Story of Youth Told by Age*, signaling the way the inventor could merge observation of nature with metaphysical speculation:

> He had a black cat named Macak when he was a boy. The cat followed him everywhere. And one day—when he stroked the cat's back, he saw a miracle—a sheet of light crackling under his hand. Lightning in the sky, his father explained, is the same thing as the sparks shooting from Macak's back. And Tesla asked himself: "Is nature a gigantic cat? And if so, who strokes its back?"

(What does *Macak* mean? I asked Sofija Mesicek, our miraculous Serbian wardrobe designer. *Macak* means cat, she explained.)

I inserted an actual black cat in three separate scenes and, accordingly, we cast a kitten named Luna. After being required to carry the creature in her arms during a brief scene, Eve was smitten. Before the film was wrapped, she purchased Luna from the folks at All Star Animals, and now occasionally sends me cellphone photos documenting Luna's unearthly beauty.

Luna, aka Macak, in 2019. Photograph by Eve Hewson.

3 BROADVIEW TERRACE

AMBITION Always "insane" unless it is "noble."
—Gustave Flaubert, *The Dictionary of Received Ideas*

My first acquaintance with Nikola Tesla—the first time I heard the name—came courtesy of Alex Toth (rhymes with "both," he would tell you), a comic-book artist I befriended when I was an unhappy sixteen-year-old.

We don't need to dwell on the source of my unhappiness—it was commonplace adolescent misery, more or less, embraced with a kind of masochistic commitment—though I can provide some context: my family moved from Kansas to California when I was thirteen and I saw

The author, in happier times, circa 1971.

myself as a displaced Midwesterner, a languishing would-be whiz kid imprisoned in the sun-struck playground of Newport Harbor High School. There was no ready cure for my condition but I typed a handful of letters to people, mostly men, whom I somehow imagined could stretch the corners of my prison. Ray Bradbury and Chuck Jones agreed to see me and we met one afternoon, the three of us, in Bradbury's Los Angeles office; I brought a tape recorder and I can still picture the red-and-black cassette labels and recall a few keen aphorisms Jones entrusted to me and the slowly churning machine. (The creator of Marvin the Martian, Road Runner, Wile E. Coyote, and Pepé Le Pew expressed deep admiration for Mondrian. He also carefully explained that you can always tell a good artist from a not-so-good artist because a good artist is always apologizing that his art isn't better.)

I spent months transcribing and editing the conversation but, in a frenzy of self-conscious perfectionism, dithered, stalled, and never shared the result.

Upon receipt of my letter, Alex Toth invited me to his house on Broadview Terrace—I always liked that name—set low in the Hollywood Hills. Though I was an impossibly serious, saturnine kid, we got along well enough for him to keep inviting me back. Alex was forty-eight, a transplanted New Yorker and self-described curmudgeon. He was pale, mildly overweight, had a handsome, somewhat thick-featured face, and he carried himself with an air of weary rectitude. He could hold forth at length, with the tender, caustic, self-righteous certainty of a radio talk show host, about anything that concerned him, which was

Alex Toth, self-portrait, mid-1970s.

principally the pleasures and sorrows of working in the comic-book business. He had weathered various professional storms across many decades while painstakingly illustrating thin and innocuous stories, a cavalcade of clichés. All the same, he could draw anything from any angle without resorting to references; his drawings were beautifully spare, stripped to sharp lines and elegant blocks of black; no one in comics was better at applying a cinematic savvy to the use of shadows and silhouettes. And though he was unmistakably superb at what he did, true to Chuck Jones's edict, Toth was seldom if ever satisfied with his work.

I should probably explain that I had imagined, since boyhood, that my own modest knack for drawing would translate into a comic-book career, though I was veering wide of that ambition even when I wrote to Toth; that was part of the point—I was searching, desperate and adrift, and Alex was sympathetic. In any case, we found things to talk about. My many visits to his house—he almost never, it seemed, ventured outside of it—have blurred together in my memory, but I can savor an element of unconscious comedy running along the edges of the relationship. I'd bring him books and photocopies featuring work by artists I hoped he'd appreciate. Manet's illustrations for Poe's "The Raven," for instance. Could he not see the striking resemblance to Noel Sickles's *Scorchy Smith*?

For Alex, the three years Sickles devoted to this comic strip, from December 1933 to November 1936, constituted one of the highest achievements of Western civilization. Extracting from a 1977 Toth

Noel Sickles, a panel from *Scorchy Smith*, 1936.

ENVELOPED IN THE SPREADING, CHOKING GAS FUMES, MASON'S MEN FIRE BLINDLY DOWN THE HALLWAY....

11-6

interview now floating online, you can catch the style of his run-on patter, the earnestness and ardor if not the tone of ready irritability: "What I learned from Noel was . . . an appreciation for economy, clarity, line, mass, pattern, perspective, dramatic moment, subtlety, light source and drop shadow mechanics, negative and positive silhouette values, shapes and the overlapping of same, tension."

I had also, I remember, developed a fascination with Käthe Kollwitz and brought examples to Broadview Terrace for Toth's delectation. Kollwitz, after all, excelled at the kind of high-contrast compression and dramatic tension that Alex advocated, though she applied these formal virtues to figures and feelings of untamable anguish, territory not commonly visited in comic books. Didactically, no doubt, I explained how I wanted to imagine contemporary comics delivering images with this level of intensity.

Alex gave me a page of original art from *The Land Unknown*, his Dell Comics adaptation of the 1957 movie, showing men in a helicopter encountering a low-flying pterodactyl. I was delighted by the gift—and especially impressed with the panel depicting the silhouetted chopper grazing the reptile's silhouetted wing, an implied shredding action achieved with daubed-in white paint and a delicate assault on the paper, he explained, with an X-Acto knife. But I continued to cajole him: Couldn't he find his way towards taking on grittier, less juvenile subject matter? Couldn't he find a story requiring a more personal stake?

Käthe Kollwitz, *The Last Thing*, 1924.

II/8 Kollwitz

In my memory, we're in his living room; the shades are drawn against the sun, and he's planted at his uptilted drawing board, chain-smoking, as he always was, and it's so hot he's not wearing a shirt. I don't remember why or how the conversation slipped from the usual flow, talk of classic movies, illustrators and comic strips, but he brought up Tesla with a tone of awe.

I can't recall a single political opinion issuing from Alex's mouth, but his take on Tesla, inspired by John J. O'Neill's stirring, hyperbolic, unfootnoted 1944 biography, *Prodigal Genius: The Life of Nikola Tesla*, assumed that Tesla's work in Colorado Springs was as revolutionary, confirmable and complete as the inventor claimed. If Tesla's plans had only been respected, financed and implemented, energy and light would be shared throughout the world via his miraculous global system, liberating humankind from poverty, inequality, and want. But the usual oppressive forces, small-mindedness and greed, had thwarted and punished him. And upon Tesla's lonely death in his New York hotel room, the FBI had rustled in and violated the safe containing his secret papers, effectively kidnapping the utopian future that still awaits us. The world we're living in now, Toth insisted through a seethe of cigarette smoke, is a dark, compromised place, absent the illumination provided by this great and mysterious man.

Alex Toth, panels from *The Land Unknown*, Dell Comics, 1957.

SUDDENLY...

WH-WHAT WAS THAT?

4 AN ACTOR PREPARES

Adolescent alienation lingered long into my twenties, during which I adopted Stephen Dedalus's credo: *Silence, exile, and cunning.* I wish I'd carried this into the world with an air cushion of self-mockery, but I tried to hold both the credo and the cushion in mind while revising the script, roughly thirty-five years later, to get within the vicinity of Tesla's troubled interior. So the script gives Tesla a surplus of resentful silences, and I relayed my pet theory to Ethan, that Tesla was a cat, Edison a dog. Tesla is withdrawn, recessive, internal. *He slinks and stares. Look at these photographs of James Joyce, the feline slouch, the elegant arrogance.*

James Joyce in Paris, photographed by Sylvia Beach, June 16, 1925.

Ethan correctly insisted he needed more than silence to build the character, to inhabit the man. I added lines, adhering closely to Tesla's published statements and quotes, and I constructed three letters read in voice-over—directed to his friend and assistant Anital (Anthony) Szigeti, to Anne Morgan, and to Anne's father. (The letter to J. P. was derived from Tesla's actual plea.)

Half a dozen of Tesla's best lines in the movie come from Ethan. My favorite of these arrives when Szigeti learns that the young woman who has just left the lab is the daughter of one of the wealthiest men in the world. I had Szigeti, startled, say: "A woman like that can make all your dreams come true." To which Tesla/Hawke replies: "All my dreams are true."

The line is moving, in my estimation, as it identifies Tesla's supreme confidence that the world of his dreams is verifiably the true world, latent, ready to spring to life. The line also signals the self-delusion that overwhelmed his future schemes. Ethan's simple, self-assured delivery of the line became one of my favorite moments in the film.

And when Anne Morgan taunts Tesla with the fact that Sarah Bernhardt travels with, and sleeps in, a coffin, Ethan came up with: "I would like to have a coffin."

We were still a few months away from shooting when Ethan reasonably, conscientiously asked to have pre-production funds allotted for half a dozen sessions with his voice coach, to nail Tesla's accent. This was approved. I also spoke with Aleksandra Vrebalov, a tremendous composer who happens to be Serbian; she coaxed fellow emigrants to record Tesla quotes into their

phones. I passed the results to Ethan—and he proved less than receptive. Tesla, he determined, "should not sound like a cab driver." He canceled the plan to work with a coach—I wasn't too alarmed; money saved!—and with due deliberation he crafted a voice based on "the most intelligent person I know," Tom Stoppard, whose purring Czech/British accent I'd heard him impersonate before. I received iPhone previews. This Stoppard/Tesla accent seemed more expressionistic than I'd bargained for, with rolled Rs and a bit of a lisp, but I agreed that it was compelling and plausible—that Tesla, working in Strasbourg and Budapest, might well have acquired a British accent with eccentric inflections and shadings. Once we started shooting, the Stoppard impersonation relaxed, and Ethan settled into a less conspicuous approach, a low growl, almost a non-accent, though more careful and caustic than his usual voice.

Along the way, I became obscurely aware that Ethan may have been channeling the director's unconscious, catlike, staring-into-space mannerisms, but I'm hardly the best person to assess this.

5 TESLA MEETS MANDRAKE

A large mirror—so at first it seemed to me in my confusion—
now stood where none had been perceptible before.
—Edgar Allan Poe, "William Wilson"

My first professional screenwriting job, late in 1982, was for a now-defunct independent studio, Embassy Pictures. They were looking for a quick rewrite of Julien Temple's take on *Mandrake the Magician*. Encouraged to provide a fresh angle, I presented them with a top-to-bottom overhaul, a detailed treatment with elements cribbed from Fritz Lang's *Mabuse* films. Incredibly enough, they went for it. As the story was set in Manhattan, it made sense for me to be flown there (my first first-class flight, sharing the cabin with Stevie Wonder and his entourage). I brought my portable typewriter and was installed in the Chelsea Hotel.

I'd been warned that theatrically performed magic doesn't work in movies —that's why, despite the comic strip's endless run, there had never been

Cover for *The Official Mandrake* #1, 1989, written by Lee Falk, drawn by Phil Davis.

a *Mandrake* film franchise or much of a tradition of successful magician movies. *Audiences know magic is not real.* On a movie screen, the baffling and exhilarating thrills of live performance get traded for camera tricks and special effects conjured in post-production. The tension between illusion and belief crumbles. My instinct to overturn this objection was to indulge the anything-goes aspect of Mandrake's hypnotic powers, to make the screenplay an exploding clown car of surreal images involving unlikely architecture, animals and deranged weather. Ronald Reagan was in the early years of his presidency and I steered the film's climax onto the roof of the White House, with a giant squid descending from inky clouds onto the Capitol dome, red tentacles ensnaring the caped and tuxedoed hero.

Of course, it occurred to me that Mandrake was an art deco Tesla doppel-gänger, dashingly heroic while upholding an outmoded Victorian primness, and I thought of the script as a secret Tesla spoof. (I liked Julien Temple's initial idea of casting David Bowie as Mandrake; the studio wanted Kevin Kline.) The essential *Mandrake* characters—the noble magician trained in Tibet, his loyal, massive, bald African pal Prince Lothar, and the glamorous, constantly imperiled Princess Narda—were invented by twenty-three-year-old Lee Falk in 1934, and Falk had the distinction of creating a second iconic strip, *The Phantom*, two years later. Given an audience with the seventy-one-year-old Falk in his Upper West Side apartment, I chiefly recall his pride in directing my attention to framed photos on the walls, including ardently autographed portraits of Federico Fellini and Alain Resnais. As Falk didn't draw his comics himself, I may have felt less spellbound in his presence than I now, retroactively, wish I'd been.

Rustling around online, I find an essay by Magnus Magnusson pointing to qualities in *Mandrake* I appreciated then and tried, at least half-consciously, to pack into my screenplay:

> In many cases one can explain the stories of Falk as a veritable hallucination, where Mandrake's magical gesture changes the perspective of what we see and thus increases our empathy and understanding of life. The reality is understood by the opposite or its mirror image. The reality is a reflection that is not always so clear.

The internet also tells us that Falk's Phantom was the first comic strip superhero to wear a form-fitting costume and a mask eliminating the character's pupils. The pupil-less eyes, Falk explained, were derived from ancient Greek statues, before he learned that the pupils had originally been painted in. And so we have a history of haunted-looking eyeless superheroes who appear simultaneously soulful and soulless.

I gave myself a deadline of three weeks, adhering to a regimen that required round-the-clock typing and post-midnight breaks for black coffee and French fries at a diner across the street from the hotel. Drafting scenes into a lined yellow notepad, I came to realize that my fellow night owls in adjacent booths were mostly sightless men and women, residents of a nearby home for the blind, as if, in a transposition of Mandrake's Mirror World, a spell had been cast, probably prompted by Stevie Wonder, inviting blind people to benignly invade my sleep-deprived world. I remember being impressed with how unlined and cheerful their faces looked, the lustrousness of their

TODAY AS ALWAYS BEFORE, STRIKING SUDDENLY, MYSTERIOUSLY... THE PHANTOM WORKS ALONE!

hair reflecting pink and green neon from the diner windows. And I was cheerful, too, feeling lucky for once, on track after a term of uncertainty and unemployment.

Upon delivering the script, I was rewarded with a wave of congratulations from the executives, though the project's producer, Éric Rochat, an amiable Frenchman who'd brought them the property, admitted an undertow of unease, due to an abrupt change in corporate ownership; Embassy Pictures' new boss was now reassessing Mandrake's future.

My memory jump-cuts to a suitably surreal denouement, once I returned to LA. I was sitting in the shade beside the Chateau Marmont's placid swimming pool, where Éric had designated to meet; he was late and I couldn't help but overhear a middle-aged man in white swim trunks, horizontal in a sunny lounge chair, reciting dialogue to a woman in a yellow bikini, who took dictation in a notepad. The dialogue was indistinct but punctuated at regular intervals by two clear names, "Tesla" and "Edison." The man had a European accent, and was voluble, rattling away, so the names ricocheted clearly: "Tesla —Edison; Tesla—Edison." The sun flared off his pale body as he spoke; he seemed to be glowing.

When Éric sauntered over—he was a slim, winsome man in his forties, with a cap of tousled dark hair, dressed that day in tennis whites, swinging a racket—he sat down and laid out the latest *Mandrake* development with fatalistic matter-of-factness. The new Embassy president was not going to read my script. He let it be known that there was one comic strip he couldn't stand when he was a boy, and it was *Mandrake the Magician*. The project was

dead in the water. "I fucked the wrong woman!" Éric said. Meaning that he'd seduced the previous studio boss, figuring he was the mogul who needed to be convinced, but he now realized the effort had been in vain.

I asked Éric if he knew the guy in the white trunks across the way, with the woman in the bikini, as they had just stood up and were gathering things to go. "No," Éric said. When I explained why I wanted to know, Éric was quick to walk over, intercepting them beside the pool; he introduced himself, then gestured for me to join them.

And so, rather miraculously, I met the great Polish director Jerzy Skolimowski, who was in Hollywood for a week, working on a Tesla screenplay. I remember Jerzy's skeptical tough-guy squint as I told him I had a Tesla script too. He offered to read it—this, I now realize, is the real miracle—and with relative speed and humility he agreed that my screenplay was better, and persuaded his Santa Monica-based producer that we should join forces.

In due time, early the next year, I was flown to London and worked with Skolimowski on script revisions for three weeks, arguing amicably until we arrived at a hybrid draft, dimly titled *Lightning*. Almost instantly, the financing collapsed—the principal producer had lost his shirt backing an extravagant theatrical flop—and Jerzy went on to another project. A clichéd outcome, not particularly startling or tragic. Even then, I preferred to direct the film myself.

I hadn't thought of Lee Falk much, if at all, for many years, when, in 1995, my friend Jamie Bishop scored a job in the prop department on a big-budget Paramount movie filming in Thailand. The movie was *The Phantom*, reconceived as a cheerful blood brother to *Raiders of the Lost Ark*. Knowing it was the kind of thing I'd appreciate, Jamie brought back a letter delivered to the production office after the movie wrapped—a handwritten missive on blue-lined note paper, penned by a park official presiding over the jungle where the film crew had built and then, of course, exploded, an elaborate suspension bridge.

> Refer to our deal in the early shooting schedule. If we could have your kind cooperate to arrange the stuff to worship the spirit of the jungle (as I listed) at Rope Bridge location. We would be very much appreciate for your coperation.
>
> 1) 1 cooked whole pig head
> 2) 2 cooked chicken
> 3) 5 eggs
> 4) 2 whisky 40 degree
> 5) 500 firecrackers
> 6) fruit & desert

I saved this letter for a while and, as you see, copied it out word for word, as the sacred recipe served, in its finely noted details, as a humble reminder that movies routinely begin with a screenplay but they never end there. Local reality has a tendency to outshine our desperate imaginations, and there are always higher powers hovering overhead.

FADE IN:

EXT. THRESHED FIELD - DUSK

Clouds are low and huge along the horizon. The
field in the draining light has a desolate flayed
appearance. Dirt raised by wind seethes up from
the ground, bits of chaff glittering like sparks.

An empty grain sack flaps into view, its mouth
billowing open.

ANGLE ON NIKOLA TESLA

A young man with thick dark hair and a short mustache.
His eyes are shut; his head lies on bare dirt.

EXT. CONSTRUCTION SITE - LATE AFTERNOON

TITLE:
UPSTATE NEW YORK, 1887

GEORGE SCHERFF stands leaning against the side of
a shack, smoking a cigar: a tall, big-shouldered man
in his mid-thirties, wearing a white shirt, tie,
pressed pants. Behind him, a dry rutted plain
extends for miles to the horizon: scattered con-
struction materials, the beginnings of a mining
operation. The sun is low and hot.

EXT. CONSTRUCTION SITE - DIFFERENT AREA

The FOREMAN stands beside an ASSISTANT, a younger
man, kneeling over a prostrate, black-clothed body.

 FOREMAN
 What happened?

The Assistant stands up, allowing a view of the
prostrate man's face. We recognize Tesla from the
earlier shot. He is very tall, gaunt, wearing a
worn black suit with a ripped sleeve.

 ASSISTANT
 Stepped out of line. Crandall
 hit him upside the head with a
 shovel.

 FOREMAN
 Is he dead?

 (CONTINUED)

The first page of my first draft, 1980.

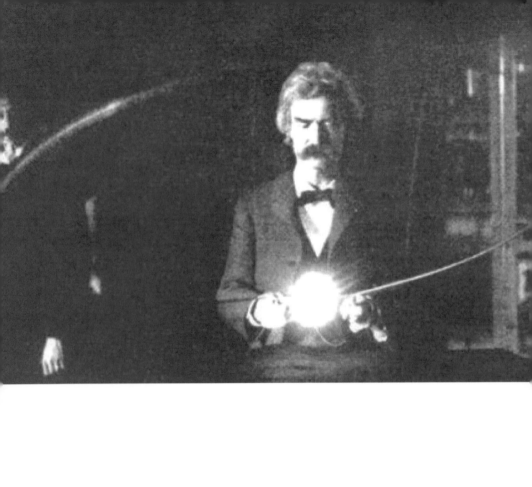

6 TESLA AND TWAIN

I wanted to highlight Tesla's social conscience, to bring out the underlying utopian drive that had, I first figured, motivated his scheme for worldwide wireless energy. But, over time, it was hard not to conclude that I'd imputed to Tesla an activist's sense of righteousness, anger, and even a streak of socialistic fervor, hearing in his proclamations a cry for universal equality and justice when the inventor's true motivations were more narrowly scientific. I adapted sentences from things he'd written, to allow glints of noble purpose to show through the sheer obsessiveness. In the scene where he and Szigeti demonstrate a prototype crafted from a tin of shoe polish, Tesla declares "This motor will do the work of the world. It will set men free." Late in the story, fastidiously wiping down a teacup as his hopes and finances are fraying apart, Tesla describes his intention to bring energy and light to the most blighted places on earth. The dialogue comes from my first draft.

Tesla with Mark Twain in the inventor's South Fifth Avenue Laboratory, New York, 1894.

I had adhered, up to a point, to Tesla's claims in a fervent, self-promotional magazine article but, reviewing the published text, I regret whittling it down; Tesla's original language is so assured and expressive:

> When the first plant is inaugurated and it is shown that a telegraphic message, almost as secret and non-interferable as a thought, can be transmitted to any terrestrial distance, the sound of the human voice, with all its intonations and inflections, faithfully and instantly reproduced at any other point of the globe, the energy of a waterfall made available for supplying light, heat, or motive power, anywhere—on sea, or land, or high in the air—humanity will be like an ant heap stirred up with a stick. See the excitement coming!

Comparing humanity to ants stirred up with a stick does not signal compassion, or clarity of mind, and falls short of being a transcendent rallying cry, but I let the analogy stand, recognizing a kind of fundamental pathology in it. And I inserted phrases about reaching out to people who are impoverished and underprivileged. Why not give the man the benefit of the doubt? Why not allow that his ideas and principles, if activated and fulfilled, might still have revolutionary consequences?

All the same, I found myself recoiling from the Victorian primness and aristocratic posturing Tesla demonstrated in his heyday, when money was flowing and, outfitted in tailored suits, gloves and boots, he moved into the most ostentatious hotel in town, dined at Delmonico's nearly every night, and courted millionaires to underwrite ongoing research. Who were Tesla's friends and allies at that time? As noted earlier, the hub of his social

circle was provided by Mr. and Mrs. Robert Underwood Johnson. Robert commissioned the grandiloquent Tesla essay for *The Century Magazine*, and Tesla traded pet names with the couple—Robert became Luka, Katharine was Mrs. Filipov—arising from their shared enthusiasm for a jingoistic Serb ballad Tesla translated for Robert's *Century* readers, eleven stanzas of confident doggerel recounting the sacrifice of a Montenegrin folk hero felled by Turkish infidels. (I found this too cloying to include in the movie.) The Johnsons hosted carefully crafted dinner parties at their Lexington Avenue home, inviting an international array of vivid cultural figures: Rudyard Kipling, Antonín Dvořák, Ignacy Paderewski, John Muir, and Samuel Clemens, aka Mark Twain.

Mark Twain's books had been Tesla's salvation when he was a bedbound young boy suffering from a near-fatal spell of malaria, or so he told Twain, reporting in his autobiography that the writer received this news with tears in his eyes. What's verifiable is that in the spring of 1894, Twain accompanied Tesla to an after-dinner demonstration in Tesla's lab on South Fifth Avenue (now West Broadway). A series of photographs immortalized the event, with the writer, shaggy-headed and debonair, triggering a glowing vacuum lamp activated by a loop of wire. Tesla is a phantasmal beanpole, visible in the background in two shots.

Over a hundred years later, comic-book artists and sci-fi fabulists have extrapolated from these photos and residual anecdotes, partnering Tesla and Twain as a crimefighting, mystery-solving team, a steampunk variation on Holmes and Watson or outright superheroes surfing time warps to save the world from interdimensional threats.

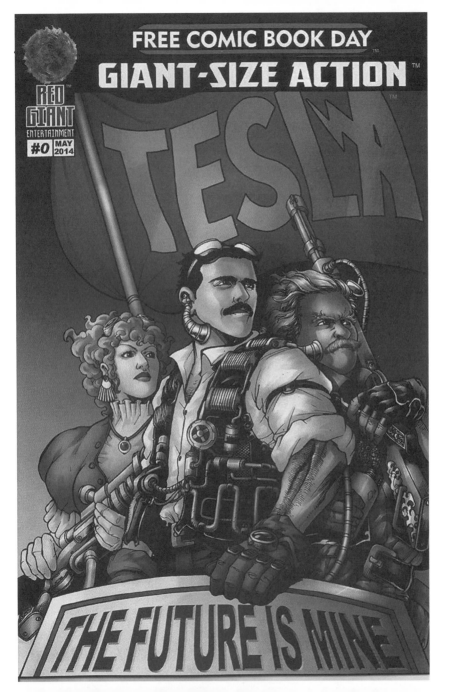

In Red Giant's *Tesla*, published in 2014, the great inventor "along with his trusty side-kick, Mark Twain, must battle the nefarious forces of the Illuminat as led by the evil genius, Thomas Edison." Completely coincidentally, one of my stalwart producers, Isen Robbins, helped publish the extant two issues, and he passed me a complimentary copy. The premier cover portrays Tesla and Twain as barrel-chested tough guys, their sleeves rolled to reveal meaty forearms connecting to upholstered leather gloves fit for motorcyclists. They're in the company of a determined young woman with a high ruffled collar, gripping a rifle that looks borrowed from Buck Rogers. I had been hoping to find it all charming, gravity-defying and fun, but no such luck.

Mark Twain was in my first draft of the Tesla script, in a montage recreating the lab photos, a spectral presence meant as a kind of benediction while illustrating Tesla's upward mobility in the Gilded Age. But why stop there? What if Twain and Tesla had something to say to one another? Twain's persona —scruffy, laconic, tolerant yet thorny—might make a perfect foil for the inventor's guardedness, might loosen him up.

I read, rummaged, and learned that in 1885, ten years before Twain met Tesla, shortly after the publication of *The Adventures of Huckleberry Finn*, the fifty-year-old author supplied a young Black man with money to pay his way through Yale Law School. Warner T. McGuinn, three years younger than Tesla, was then twenty-six years old.

What happened to this bright young man? After graduating from Yale, McGuinn edited a Black newspaper in Kansas City, Kansas, moved to Baltimore in 1890 and took up work as a lawyer. In 1917, the *New York Times*

The first of two issues from Red Giant Entertainment, 2014. Cover art by Bong Dazo.

tells us, McGuinn "scored a major legal triumph by successfully challenging in Federal Court a Baltimore city ordinance that mandated segregated city housing." The same *Times* article quotes Thurgood Marshall, who shared adjoining offices with McGuinn early in his career: "He was one of the greatest lawyers who ever lived . . . If he had been white, he'd have been a judge."

Another newspaper report, following McGuinn's commencement address at Lincoln University in 1933, grants him a few quotes, revealing a Twain-like twang of country wisdom when he commented on the current state of the legal profession:

> Some of these fellows are so slick they can take the salt out of biscuits without disturbing the covers . . . Unless entrance examinations are changed so as to include character as well as knowledge, the practice of law will degenerate into a dog fight.

When McGuinn died in 1937, Twain's generosity was a rumor, only to be confirmed when a letter to Yale's Dean Francis Wayland was discovered and reproduced on the front page of the *New York Times* in 1985. Enquiring after McGuinn, Twain had written:

> Do you know him? And is he worthy? I do not believe I would very cheerfully help a white student who would ask a benevolence of a stranger, but I do not feel so about the other color. We have ground the manhood out of them, & the shame is ours, not theirs; & we should pay for it.

McGuinn's obituary states that he and Twain "remained friends until the author's death." As with the Tesla–Twain relationship, you have to wonder about the precision of this definition of friendship; Twain was a sociable celebrity, one of the most famous beings on the planet, but readers of Twain biographies know that, like most of us, he had few intimate friends.

In 1896, determined to escape massive debt, Twain embarked on a worldwide lecture tour. When his twenty-four-year-old daughter, staying behind in Elmira, New York, fell ill and died of meningitis, Twain dropped into a deep depression and stayed away from the United States for over five years. "I think we are only the microscopic trichina concealed in the blood of some vast creature's veins," he wrote in a notebook a dozen years earlier, "and it is that vast creature that God concerns himself about and not us." Justin Kaplan extracted this line in *Mr. Clemens and Mark Twain: A Biography*, noting that Twain "spent hours at the eyepiece" of an English brass microscope trained on drops of rainwater or blood. How might Tesla, a fellow student of nasty microbes, have reacted if Twain confided his irrepressible pessimism, setting the stage for a discussion of bacteria and fate?

Or what if everyone's favorite famous author brought Warner T. McGuinn to witness Tesla's private laboratory display? How would the inventor and his high-end audience respond to this singular fellow? How might the conversation acknowledge or ignore questions of conscience, equality, injustice— questions riding just below the surface of Tesla's prophetic projections? What if Twain unleashed sentiments expressed in his letter to the Yale dean? Well ahead of 2020's necessary uprising, I was feeling uncomfortable

making a movie bound within such a circumscribed world, where these undercurrents remain unmentioned and out of sight.

I wanted Sam Shepard to play Mark Twain. We talked about it. I figured Sam's caustic frontier fatalism could fuse with Twain's and provide an interior ripple within the film's nervous system, since Sam had played Ethan Hawke's father in a couple movies, including our *Hamlet*, over twenty years earlier, and Ethan and Sam had a long, eventful history.

Sam had consented to other post-*Hamlet* collaborations that never happened, the most concrete being a short film I'd written for him, a six-page script based on a late Borges story ("December 25th, 1983") in which a man arrives in a hotel room to find his older self already there, lying in bed, informing him, rather reproachfully, that they are caught in a shared dream.

The two Sam Shepards (two *Borgeses* in the story) can't agree on which of them is the primary dreamer of this dream. The younger man, irritated, asks what the man in bed can tell him about his future.

"The misfortunes you are already accustomed to will repeat themselves. You will be alone, surrounded by the same books and memories and broken promises." But, the old man allows, they'll manage to write one last masterpiece, which he'll publish under a pseudonym—only to have it dismissed as a miserable Sam Shepard imitation.

I'd imagined this film was a neatly practical proposition because all we needed to make it was a single hotel room, a minimal crew, Sam's participation, and a

A Polaroid generated by the wardrobe department: Sam Shepard as the Ghost in *Hamlet* (2000), shot in New York, 1998.

good makeup artist to age him a dozen years or so in the requisite shots. But that didn't mean it was a snap to raise money or coordinate our schedules. When Sam told me, in February of 2016, that he'd been diagnosed with ALS, we were sharing the corner of a crowded, candle-lit West Village bar. He named and described the disease with a stoicism that seemed superhuman. I asked a few tormented questions, gave him a clumsy hug, and we drank a lot of red wine that looked black as ink.

We continued to talk about Tesla and Twain, and a small universe of other things, over the next year and a half, but his acting career was finished. I visited him in Midway, Kentucky, in his compact, recently renovated house set within a horse farm. I stayed overnight, a month before Sam died. He was a splinter of himself but vital, alert, even cheerful. He'd always liked to laugh. And we were laconic to a fault, talking around the glaring fact of his mortality. I'd become useful to him as a reader of his manuscripts, and he was deeply invested now in completing his definably last work, *Spy of the First Person*, moving through memories, flashes and fragments from the past while keeping an eye on himself in the present with a kind of astonished self-scrutiny. No longer able to use his hands, he had been dictating chapters just as Mark Twain dictated "the black heart's truth" of his autobiography.

My second afternoon in Midway, Sam offered an impromptu tutorial on the Lewis and Clark expedition, after I professed my ignorance of the subject. I knew they were remarkably young when they set out, I said, and one of them was subject to depression and probably killed himself. "Meriwether," Sam said, and called out for his sister Roxanne—a fiercely independent woman

Mark Twain with John T. Lewis, a farmer living near Twain's in-laws in Elmira, New York, 1903. (There are, alas, no photographs of Twain with Warner T. McGuinn.)

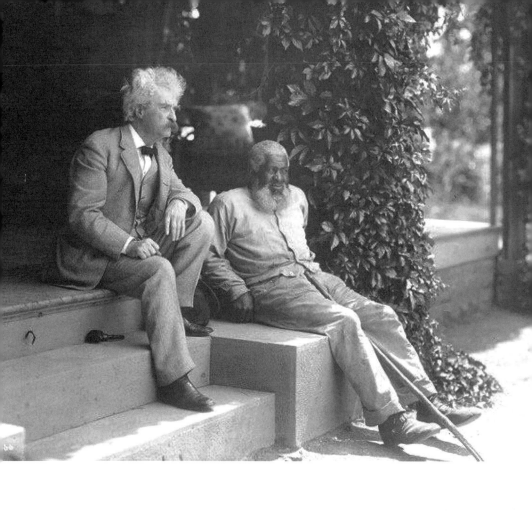

who had set aside her life in Istanbul to tend to her brother, to see him through this narrowing tunnel. Sam told her where to find his copy of the edited Lewis and Clark journals, and she brought the thick book to the big round kitchen table where we sat talking. I flip it open now—I requested the book after Sam's departure—and I land, purely at random, on this entry by William Clark, February 20, 1805:

> I am informed of the Death of an old man whome I Saw in the Mandan village . . . he was 120 winters old, he requested his Grandchildren to dress him after Death & Set him on a Stone on a hill with his face towards his old Village or Down the river, that he might go Straight to his brother at their old village under ground.

When it came time to film *Tesla*, Sam had been gone for almost two years and my imagination had sentimentally seized up. The idea of building a Twain subplot collapsed; I didn't care to think of anyone filling Sam's shoes.

All the same, the ever-evolving screenplay retained that glimpse of Twain lighting the vacuum bulb. And so I recruited Lois Smith. She'd known Sam well, having appeared in Steppenwolf's 1995 production of *Buried Child* and, in a part written expressly for her, in Shepard's *Heartless* in 2012. We outfitted her in a suitably glittering period getup and a wide-brimmed hat. Lois had no lines but brought her luminous smile. She's listed in the credits as The Grand Dame. She was the Mark Twain/Sam Shepard surrogate.

Sam Shepard and Michael Almereyda on the set of *Hamlet*, 1998. (Bearded, behind the camera, stands cinematographer John de Borman; future producing ally Anthony Katagas is up against the wall.)

7 HAPPY BIRTHDAY, ORSON

On our first day of principal photography, May 6, 2019, I attempted a brief pep talk, announcing to the cast and crew that Orson Welles would have been 104 if he were alive on this day, and I invoked Welles's description of his fantastic, impoverished, expressionistic *Macbeth* as "a violently sketched charcoal drawing" of Shakespeare's play, offering this as an index for how we'd be rushing headlong across the tightrope of our twenty-day shooting schedule—three days less than Welles had for *Macbeth*. I tried to encourage the idea that we were there to get our hands dirty. There are things you can do with a sketch, I said, that you can't pull off in a painting.

Of course, any filmmakers measuring themselves beside Orson Welles are asking for trouble, but Welles was the hero of my adolescence—not Tesla, who merely intrigued and excited me. One of the most oddly durable memories from my forlorn career at Newport Harbor High locates me in the school's refreshingly dark library, where I skipped lunch on successive days to devour *Run-Through*, John Houseman's sulfurous 1972 memoir recounting his role as Welles's early producer, detailing Orson's

Eartha Kitt as Helen of Troy, Orson Welles as Faust, in Welles's stage production of *Time Runs*, performed in Paris, 1950.

prodigal activities from ages nineteen to twenty-five, leading up to and into *Citizen Kane* (1941). Houseman first saw Welles onstage, as Tybalt in a 1934 production of *Romeo and Juliet*, and Houseman's suitably hyperbolic prose conveyed the sense of dark enchantment and even danger radiating from "the monstrous boy."

"What made this figure so obscene and terrible," Houseman wrote:

> was the pale, shiny child's face ... from which there issued a voice of such clarity and power that it tore like a high wind through the genteel, modulated voices of the well-trained professionals around him. "Peace! I hate the word as I hate Hell!" cried the sick boy, as he shuffled along, driven by some irresistible interior violence to kill and soon himself, inevitably, to die.

None of the admirable or unfortunate portrayals of Orson Welles in other people's movies convey this sense of Welles as a fearsome, otherworldly being, nor do they adequately illuminate that relatively wide streak in his persona that allowed for mischief and self-mockery. In any case, tearing through *Run-Through*, I felt aligned with the energy Houseman described, sympathetic to Welles's defiance of complacency in all aspects of his existence, even as it was apparent from Houseman's pages that there was no way to compare oneself to such a blaze of talent, energy and appetite. Even so, the portrait of Welles provided by that particular plastic-sheathed library book was counterbalanced by the spectacle of Welles as he appeared in the '70s, physically changed—a dolphin morphed into a whale—and amiably showing up for talk shows, celebrity roasts and those infamous wine

Georges Seurat, *Night Stroll*, 1887-88.

commercials. To my mind he was still heroic, an iconoclast only partially camouflaged as a showbiz hustler and shill. I was watching, riveted to the TV, when Welles accepted his 1975 AFI Lifetime Achievement Award with half-convincing humility—"This honor I can only accept in the name of all the mavericks"—while candidly trawling the audience for potential investors for his unfinishable *The Other Side of the Wind* (finished posthumously, it turned out, by multiple hands, in 2018). In this speech he also labeled himself a "raggle-taggle gypsy" and "in this age of supermarkets . . . your friendly neighborhood grocery store."

I recognized there was no easy or sensible way to separate Welles's films from their maker's outsize presence and personality, yet I also saw or sensed that the films challenge the idea of human identity, suggesting how unstable, unreliable, split or shattered our conscious selves can become under pressure. The haunting late shot in *Kane*, showing Welles's lurching, flat-footed figure rippling across an infinity of interfacing mirrors, declares the theme outright, and there it is again throughout *The Lady from Shanghai* (1947), culminating in the dazzling/devastating "Magic Mirror Maze" shootout. Nearly every Welles film, in nearly every frame, is galvanized by baroque intensity, a sense of dislocation and surprise, but the ingenious angles, shadows and camera movements project a point, lifted past atmospherics, channeling a view of the world as a treacherous labyrinth, a theater of untamable illusions occupied by people who don't quite know who they are.

I found it instructive when this virtuoso told an interviewer, with credible modesty, "A director is someone who presides over a series of accidents."

A page from
Premier Plan Hommes Oeuvres Problemes du Cinema No 16: Orson Welles, 1961.

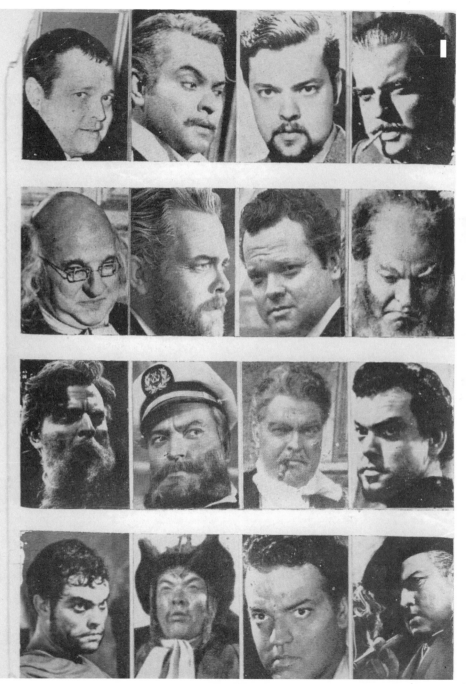

Following his itinerant years in Europe, Welles's work, his professional prospects, certainly, came to seem increasingly accidental, makeshift, improvisatory. His notions of style and control loosened considerably, and while he didn't complete another narrative picture after the AFI tribute. he embraced—was forced to embrace?—his role as a truly independent filmmaker, holed up in a Hollywood guest house, shooting an (ultimately incomplete) adaptation of Isak Dinesen's *The Dreamers* in the backyard with a skeletal crew and Oja Kodar, his sloe-eyed companion, collaboratively in or out of the frame. A Magic Mirror Maze of a life.

My impressions of Welles during this late period, shortly before he became, in Don DeLillo's phrase, a dead living legend, are tempered and sweetened by the recollections of Robert Kensinger, Welles's personal assistant for roughly eight months in 1979, when Bob was twenty-two and Orson and Oja occupied a small tract home on Wonderland Avenue (less than fifteen minutes from Alex Toth's Broadview Terrace). Bob's experience behind the wheel of Welles's Chrysler convertible—they always drove with the top down, Bob said—trumped any other qualifications he may have offered when I hired him, in 1985, as production designer on my first film, a self-financed short.

Welles, in Mandrake mode, had been using *his* own money, Bob recounted, to film magic tricks in TV studios with Burt Reynolds and Angie Dickinson. He kept a row of hollowed-out, artificial thumbs standing upright on his bedroom bureau—false thumbs being essential props when performing sleight of hand—and he was otherwise consumed trying to conjure funds for movie projects. Bob's enchanting, inevitably comic memories included a rare interval of intimacy when the young man accompanied Orson to Don the

Beachcomber, a Polynesian/Hollywood dining palace where the staff led Mr. Welles to his favorite table, presented him with his engraved gold chopsticks (enshrined in a display case with chopsticks belonging to other, mostly deceased, famous people) and Welles announced, with his magnificent voice: "I'll have the Kung Pao chicken, and the same for my son here . . ."

This in contrast to the fury Bob withstood when he quit Welles's employ to work on a rewrite for a Roger Corman movie, explaining that he had come to L.A. to direct: "Bob, don't waste your time—you will never be a director. YOU WILL NEVER DIRECT! . . . It's my duty to tell you how impossible it is to get that job in this town."

(Surfacing, as if on cue, within the pandemic's time-bending whirlpool, Bob has recently reached out to me and shared chapters of his forthcoming memoir, *Action at a Distance*, though I've plucked the above dialogue from Kristine McKenna's Kensinger interview in *Talk to Her*, a 2004 collection.)

So—I'm hardly alone in considering Welles an unreachable, unappeasable surrogate father, signaling the best and worst of what the future may bring. When he died at home, October 10, 1985, I was shooting in Val Verde, about a half hour north of Los Angeles. The news arrived during our lunch break, and I remember staring into the barbecue pit, at the smoking, glowing coals. I blinked away tears—then went back to presiding over a series of accidents.

"All of us will always owe him everything," wrote Jean-Luc Godard. I can only speak for myself.

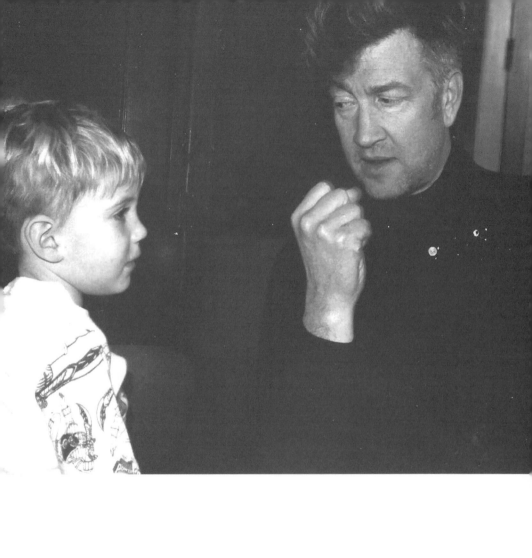

8 PLENTY OF PIE!

"I would like one American meal for a change—plenty of pie."

When Thomas Edison expressed this sentiment on a cruise ship heading to Paris in 1889, scorning the sparse continental breakfasts he'd been served upon leaving New York, he was not making a reference to *Twin Peaks*. All the same, the scene in *Tesla* in which Kyle MacLachlan cheerfully echoes these words has been taken as a tribute to the David Lynch series.

Which is only fair, since Lynch (and Mary Sweeney, his editor at the time, and eventually his wife) blessed me with a spell of patronage in the early 1990s, for which I'm abidingly grateful.

I tend to think of David Lynch and Thomas Edison operating on parallel wavelengths. Both are/were shy extroverts, nicotine-addicted polymaths,

Riley and David Lynch in their Hollywood home, 1993, photographed by Michael Almereyda.

irrepressibly original, charismatic, and notably good at branding themselves. Their fame and glory can be half accounted for by a shared, uncanny combination of American matter-of-factness and a ready acquaintance with unassailable mystery. They convince us they're in steady contact with thresholds and latitudes of higher reality, screened through a portal of charming literal-mindedness. Lynch's films frequently contain fluttering lights, buzzing wires, and electric-powered machines that emanate smoke and menace, and it's curious that, in his most sustained acting role, as FBI deputy director Gordon Cole in the *Twin Peaks* universe, Lynch plays an authority figure as endearingly, inconsistently deaf as Edison, who lost most of his hearing at age twelve yet managed to invent the phonograph when he was thirty, and continued to refine sound-related technology for the rest of his long life.

Edison, of late, seems to be suffering a public relations backlash, dating from somewhere in the late twentieth century, with his reputation as a modest folk hero (cf. the 1940 Spencer Tracy movie) tarnished in the wake of various credit disputes and the blunt reality that he sponsored the electrocution of dogs, calves, and horses in an attempt to undermine the rival AC technology of Tesla and Westinghouse.

Having waded into this discussion a few times before, I feel compelled to insist that Edison did not kill an elephant. The seventy-four-second 1903 film *Electrocuting an Elephant*—which eerily resembles images in Lynch's 1980 *Elephant Man*—was produced by Edison's newsreel team, standing by with many other representatives of the press to document the execution of Topsy, a tormented elephant exploited by her Luna Park employers. (Topsy

Topsy being led to her fate at Coney Island, 1903.
Frame grab from *Electrocuting An Elephant*.

had trampled three men in one month, the last being a drunken trainer who inserted a lit cigarette into her trunk.)

The director of *Electrocuting an Elephant* was uncredited, but the film—composed of two haunting shots—is attributed to Edwin S. Porter, director of *The Great Train Robbery,* produced that same year (and anachronistically viewed by Tesla in the Edison pie scene at almost exactly the point when Anne Morgan announces the two men did not, in fact, dine and reconcile at the World's Fair).

Electrocuting an Elephant may be the first death recorded on camera in real time. Topsy received a surge of electric current through copper plated sandals on a wired steel platform. She stiffens as the current strikes, but the awfulness of what's happening is mostly apparent through gusts of smoke billowing up from the creature's feet, as if the elephant were a rocket about to launch into the air. She topples, instead, to one side, enveloped in drifting smoke.

This film was made available to the general public via the kinetoscope, the cabinet-sized, peephole-accessed viewing box that Edison developed with William Kennedy-Laurie Dickson (four years younger than Tesla) in 1889 and installed in arcades for the next half dozen years, a brief anticipation of single-player video games, popular for an interval in the late nineteenth century before theatrical film projection took off. Wikipedia also reports that *Electrocuting an Elephant* didn't attract as many viewers as other Edison Actualities of the same vintage.

Thomas Alva Edison with optical devices and lenses, 1893, photographed by W.K.L. Dickson.

copyright
W.K.L.Dickson
'93

That said, apart from placing his name on the film's presentation card, Edison had nothing to do with Topsy's dismal demise, which was unrelated to the battle of the currents, whose last skirmishes had concluded ten years earlier.

But I digress.

When Tesla arrived at Edison's Machine Works in 1884 with a letter of recommendation addressed to the great man, Edison was just thirty-seven years old but one of the most famous, successful, and anomalous figures on the world stage. Tesla, nine years younger, was a promising apprentice nursing a radical idea for an alternating current motor, a technological marvel whose practicality was as unlikely as it was unproven. Both men were brilliant, willful, far-seeing, science-obsessed egotists and idealists, but they were distinct opposites in temperament and style. And they were not, at the outset, standing shoulder to shoulder. If Edison failed to recognize Tesla's prodigious talents, he might be forgiven when we factor in the death of Edison's wife, which might have monopolized his attention during the summer when Tesla went to work for him. This overlap, reported by Anne Morgan in the film's narration, is my one flash of hiding-in-plain-sight scholarship, a discovery flaring up amidst the heap of familiar anecdotes. Few Tesla books treat its importance with any clarity or conviction.

My film introduces Edison in the midst of a late-night blackout, rambling about the death of a childhood friend, a drowned boy—a near-verbatim account from the historical record. (I didn't invent much of anything in the film, unless Anne Morgan tells you otherwise.) I imagined Edison would

be dazed with grief, free-associating, and that this memory might trigger in Tesla a semi-symmetrical recollection of the death of his older brother, whose cold lips he was commanded to kiss by his mother. Maybe I was overreaching, but I had to assume that encountering sudden death when you're young can shake and shape a person, even if the impact is translated in the ways you run into or away from basic questions like: *Why?* or *Why not me?*

As Edison confided to a reporter, "I like to begin at the large end of things. Life is too short to begin at the small end."

Tesla and Edison came to a dispute over a promised payment. O'Neill's *Prodigal Genius* is the source of this fundamental story, and Edison's apocryphal, throwaway line—"Tesla, you don't understand the American sense of humor" —jabs at the heart of the matter. Tesla seems to have had a talent for getting swindled and being misunderstood while projecting himself (in interviews, speeches, his memoir) as an inexhaustible Promethean visionary, diligent, disciplined, and never missing a trick. I worried that Tesla's aloofness might saturate my movie, with grains and splinters of my own melancholy spiking the portrayal. At any rate, as I saw it, the buoyant, boyish, yammering energy that Edison radiated was contrary to Tesla's saturnine reserve. I repeated the mantra, to myself and the actors: *Tesla is a cat, Edison a dog.*

But I hardly had to tell them anything. Ethan Hawke and Kyle MacLachlan were happy to be reunited, having been teamed as hero and villain in *Hamlet*. "Getting the band back together," was how Kyle described it, though I had to court him for a while, in the wake of the attention deservedly bestowed upon

Twin Peaks: The Return. I treated Kyle to coffee at IHOP on East 14th Street, and that seemed to impress him. I also supplied him with photos of Edison highlighting their physical resemblance, and he was particularly impressed with the inventor's 1885 diary, covering about six summer weeks during which Edison took an unprecedented break from work while courting his second wife, twenty-year-old Mina Miller.

Entries reveal a talent for observation vying with a vital imagination, and a penchant for sardonic editorializing, expressed with faux grandiloquence. After reading a newspaper account of two suicides and two murders, Edison writes:

> The details of these two little incidents conveyed to my mind what beautiful creatures we live among, and how, with the aid of the police, civilization so rapidly advances.

He reports on meals, weather, his extensive reading (French literature, Hawthorne, Goethe, "Lavater on Facial Philosophy"), and he recounts an occasional dream:

> In the evening went out on the sea wall. Noticed a strange phosphorescent light in the west, probably caused by a baby moon, just going down Chinaward. Thought at first the Aurora Borealis had moved out west. Went to bed early, dreamed of a Demon with eyes four hundred feet apart.

Edison's reductive critics insist he was all about money and business, that his inventions and motives were all too thoroughly enmeshed with commercial enterprise. The diary reveals he could accommodate other concerns, as does

Diane Venora (Gertrude), Ethan Hawke (Hamlet), and Kyle MacLachlan (Claudius) filming *Hamlet* **on Park Avenue, New York, 1998. Photograph by Larry Riley.**

the testimony of most any colleague or character witness you might refer to. And there's evidence that his dealings with Tesla were gentler and more generous than what you'd assume from the comic-book rivalry concocted by internet commentators, or even the picture presented in my movie.

Edmund Morris's magisterial biography—titled simply *Edison*, a dense chronicle told backwards, Benjamin Button-style—was published months after we finished shooting, but I was glad for its fresh evidence. When Tesla, having returned from Colorado, delivered a lecture-demonstration at Columbia University in the spring of 1900, Edison attended. He arrived late—prompting Tesla to interrupt himself, step down, and take Edison's hand and lead his colleague to his seat. The audience erupted in cheers.

Edison and Tesla both lived into their eighties, and in the home stretch both were subsisting on a liquid diet, drinking mainly milk. Edison remained remarkably active and productive, was considered a national treasure, attended by a loving wife, and clearheaded up to the end. None of this can be said for Tesla, whose final days were altogether grim, even if you care to celebrate the tender feelings possible between a man and a pigeon—which I chose to leave out of the movie.

I've belatedly learned that, despite his conspicuous affinities with Edison, David Lynch nurtured long-term plans for a Tesla project of his own—a stage production intended for Broadway, undertaken at roughly the same time David was helping me find my way. (Initially, Lynch lent his name to an Edgar Allan Poe movie I wanted to make; after failing to find financing, he

Kyle MacLachlan as Edison in *Tesla*.

executive produced my less-costly vampire picture, *Nadja*, paying for it out of his own pocket and delivering, in my opinion, a perfect cameo appearance as a hypnotized morgue attendant.) Beginning in 1993, Lynch employed young Eli Roth, the future writer/director/producer of *Cabin Fever*, *Hostel*, and *Borderlands*, as an undercover research assistant, pursuing Tesla lore and arcana on and off for five years.

In a cheerful text, Roth wrote "it kills me" that Lynch's project never came to fruition. David wanted to feature live electricity onstage in tandem with live music by Angelo Badalamenti. Liam Neeson was his first choice to play Tesla. Roth, a senior at NYU when the job began, recruited pals with access to university libraries to search out unpublished material.

> We didn't want anyone to know who we were working with so we used the name Mr. X, which David LOVED. We called ourselves The X Team, and the files were the X Files. This was two or three years before the TV show existed. David would address faxes and emails to us to The X Team with electrical bolts, and sign it Mr. X. It was so fun.

After *Nadja* premiered in the Toronto Film Festival, I was only too happy to offer David a partial repayment on his generosity, supplying a rewrite, at his request, of his adaptation of *Fantomas*, the French pulp serial detailing the exploits of the suave, monstrous, unstoppable master criminal. One of my cheeriest memories of that time is a family dinner at the Lynch/Sweeney household in the Hollywood Hills. David was, like

Edouard Manet, lithograph illustrating Edgar Allan Poe's "The Raven," 1875.

Tesla, particular about food. He ordered from a prized Italian restaurant on Melrose Boulevard: pasta and salad served in aluminum foil takeout containers. The meal commenced with a giddy ritual, everyone in unison lifting the round silver lids from their food and holding them high with a flourish, like hats raised in a victory parade.

David Lynch in *Nadja* (1994).

9 KISS ME BEFORE YOU WAKE UP

See shadow puppet plays and imagine that you are one
of the characters. Or all of them.
—Ron Padgett, *How to Be Perfect*

The first feature film I wrote and directed, *Twister*, was a slow fitful screwball comedy about a wealthy midwestern family splitting apart at the seams, with Harry Dean Stanton playing the imperiously burnt-out patriarch, founder of a highly successful soda-pop empire. Based, fairly faithfully, on Mary Robison's terrific 1981 novel, *Oh!*, the film was shot in the summer of 1988 in Wichita, Kansas, with a cast that also included Suzy Amis, Dylan McDermott, Crispin Glover, Charlayne Woodard, Tim Robbins, and William Burroughs.

Harry Dean Stanton, Crispin Glover, and Charlayne Woodard in *Twister* (1989).

This is not the place to inventory all the catastrophes that attended the making of this movie. I felt, with absolute conviction, that I had failed— failed to make the movie I imagined in my head, failed to make the film of my dreams.

Nonetheless, when I was invited to accompany *Twister* to the Deauville International Film Festival in 1990, I showed up, and drifted, with more than a hint of masochism, into a screening of *Total Recall*, my eyes reflexively bouncing off the French subtitles as I admired how the escalating mayhem accommodated Paul Verhoeven's sardonic touches, up through and beyond the cataclysmic climax, when Arnold Schwarzenegger and his revolutionary Martian girlfriend are propelled into the life-threatening atmosphere as the poisonous sky convulses and the terraforming planet allows them to breathe free.

"I just had a terrible thought," says Arnold. "What if this is a dream?"

"Then kiss me before you wake up," his paramour replies.

I had written these lines, just a few years earlier, for a different incarnation of *Total Recall*. A bit of pandemic-inspired housecleaning has just unearthed a copy of my contract, which reminds me that I was paid $40,000 for three weeks of work, with the understanding that the film's writing credits were pre-established and my contribution would go unacknowledged. (The arrangement struck me as more than fair. The script, developed from a twenty-two page story by Philip K. Dick, had gone through more than forty drafts by multiple hands before I took a swing at it.)

Arnold Schwarzenegger (sort of) in *Total Recall* (1990).

I remember being stationed in a bright hotel room in Sydney, Australia, laughing a great deal with Bruce Beresford, who was slated to direct the movie with Patrick Swayze in the lead. When the producer, Dino De Laurentiis, abruptly declared bankruptcy, weeks after I delivered my draft, I was impressed by how resourcefully Schwarzenegger swept in, hiring Verhoeven and retrofitting the project for himself. And I was bemused, in Deauville, to see my dialogue repurposed for the film's final lines. In the annals of pop culture mega-hits, I'm not likely to have a more significant role than this.

For all that, I was, for a span, a Hollywood screenwriter, a specialist in sci-fi, a go-to guy for futuristic stories attuned to comic-book tropes. Studio execs weren't hiring me off of *Tesla* or *Mandrake* but *Cherry 2000*, a screenplay sparked by a story supplied by Lloyd Fonvielle, a friend who had been too busy to write it himself. That story concerns a young man in a post-apocalyptic near future in Anaheim, California, an idealist whose romantic devotion to his perfect wife, a robot named Cherry, is challenged when she breaks down and he's faced with the peril of comparing her to an actual woman. When the movie got made, it was my first (and only) experience seeing a studio film start with my script and take shape through a series of committee-approved decisions. The producers treated me with uncommon respect, allowing me to watch at close hand as primary recruits—the director and main cast members —fell short of my hopes and recommendations.

Wim Wenders hired me in 1986 to collaborate on his *Until the End of the World*. De Laurentiis and Beresford, a year later, flew me to Australia to help with their Martian adventure. David Lynch, a few years down the line, tagged

Renato Casaro's poster for *Cherry 2000* (1987), a story of humans and machines.

CHERRY 2000

UNA PRODUCCION DE EDWARD R. PRESSMAN

CHERRY 2000 MELANIE GRIFFITH DAVID ANDREWS BEN JOHNSON TIM THOMERSON

Director de Fotografía JACQUES HAITKIN Montaje EDWARD ABROMS, A.C.E. y DUWAYNE DUNHAM Música Compuesta BASIL POLEDOURIS

Productor Ejecutivo LLOYD FONVIELLE Coproductor ELLIOT SCHICK Producida EDWARD R. PRESSMAN, CALDECOT CHUBB Argumento LLOYD FONVIELLE

DOLBY STEREO Copias por DeLuxe Guión MICHAEL ALMEREYDA Dirigida STEVE De JARNATT DISTRIBUIDA POR **ORION** PICTURES

© 1987 Orion Pictures Corp. Todos los Derechos Reservados.

me to revise his *Fantomas*, and Tim Burton, with Warner Brothers footing the bill, enlisted me to write an adaptation of Hawthorne's *Rappaccini's Daughter*. These were all lush, otherworldly stories spiked with violence and lyricism, dreams within dreams. The scripts also shared common threads or themes involving free will, identity, and the human habit of commodifying experience, turning people into objects, interchangeable units, machines. (Camouflaged, at the time, with jokes and genre flourishes, these themes may be more conspicuous in films I eventually directed myself.)

Total Recall and the Wenders epic were transmogrified into movies without many traces of my fingerprints; the other scripts came to nothing. I took it as a cue to tilt away from supernatural subjects or, more honestly, I was simply open to flipping the coin and reading off the other side. (I'm not convinced supernatural subjects are the opposite of naturalism, of "real life." Comic-book reality, with its hectic exaggerations and runaway mayhem, seems to be devouring mainstream American movies, to say nothing of American politics.) Inspired by another true whiz kid, Sadie Benning—an encouraging complement to Welles—I took up a plastic toy Pixelvision camera and veered into more earthbound territory, stories unfolding in modest, mundane settings, including my own apartment.

My Hollywood apprenticeship, I now realize, involved a mélange of rewrites and adaptations, conditioning me for a future of postmodern rescue operations and archeological digs, with venerable texts fitting as snugly as classic pop/trash into personalized contemporary frames. I wasn't aiming to be perceived as a marginal, noncommercial misfit, but I was busy convincing myself that the true dream is to tell stories that feel true to life, life as it

Michael Almereyda sketched on a paper plate by Yun-Fei Ji, 1993.

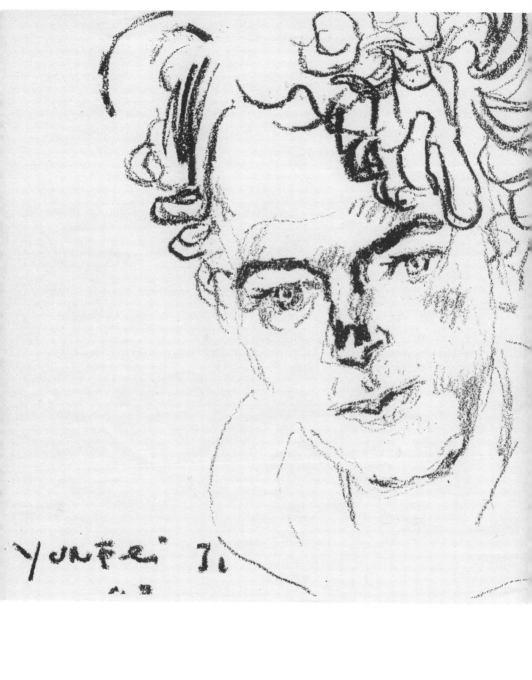

arrives on your nerves in the present tense. And I developed the conviction that the best films I could make were those that were most fully and inescapably mine, even if they emerged from the vast, untamed scrapheap of preexisting plots, characters, images.

And these notions, I wanted to believe, were consonant with Welles's idea —shared and demonstrated by Jean Vigo, Sam Fuller, Derek Jarman, Vera Chytilova, Charles Burnett, Chris Marker, Claire Denis, Wenders, Godard, Pasolini, Varda, Cassavetes, Kiarostami, Akerman, Ruiz—an international assortment of renegades and escape artists—that you can make a film like a sketch and it can be more exciting, liberating and alive than the Hollywood equivalent of a finished painting in a heavy frame. All of which has accounted, over time, for a sidewinding path that's delivered me, fearless as a sleepwalker, into tight corners and deep ditches and other places where caution and commerce don't necessarily come along for the ride. Various tender and savage producers and financiers have not managed to wake me from this ongoing dream.

Meanwhile, in all innocence, I'm ready and willing to direct the overdue remake of *Cherry 2000*.

Barry Sherman and Elina Löwensohn in *Another Girl Another Planet* (1992), Pixelvision video transferred to 16mm.

10 AN INCOMPLETE PERSON

Her expression is withholding, and thus alluring ... She seems to embody truthfulness, theatricality, and mystery—and make those abstractions compatible.
—Julian Barnes on Sarah Bernhardt, in *Levels of Life* (2013)

Perhaps the most questionable fictionalized scenes in my movie are the interludes with Sarah Bernhardt, an international celebrity, twelve years Tesla's senior, by common consent the greatest actress of her era as well as one of its most fascinating self-created personalities. Tesla in his old age allowed that in 1899, when he was in Paris to attend the Universal Exposition (when and where the Eiffel Tower made its debut), the Divine

Sarah Bernhardt in Sardou's *Theodora*, 1884, photographed by Nadar.

Sarah dropped her scarf within his vicinity. Tesla retrieved it, he said, and kept the garment, without washing it, for the rest of his life. (This scarf is not among the personal items on display since 1955 in Belgrade's Tesla Museum, in a permanent exhibit that includes Tesla's toothbrush, razor, bottle opener, bowler hat, and a crisply preserved pair of high-top boots made of green suede.)

How well did the celibate inventor get to know the legendary seductress? On a detailed, fact-stuffed website, Teslacommunity.com, you can read that, in 1892, Tesla developed "a long love relationship with Sarah . . . the only woman in his life who understands how to make love to him, playing sexual jesters with him using numbers of three."

I came across this intriguing passage years ago and have stumbled over it repeatedly before realizing, just now, that the phrase *sexual jesters* is a hapless translation, a faulty spelling of *sexual gestures*. My imagination can, at last, rest easy.

The website is promoting pure fantasy, but I invited Sarah Bernhardt into my movie to challenge Tesla's cerebral self-containment, his apparent aversion to the pleasures of the flesh. Bernhardt was the first actress, it's been written, to act with her entire body, and I imagined her as a suitable provocateur and, come to think of it, a sexual jester—flirting, flaunting her physicality, and even speaking with brazen and baffling directness about love.

"Suppose you had to cut your head off, and give it to someone else—what difference would it make? This is what love is."

This dialogue may be overwhelmed, in the movie, by a simultaneous theatrical flourish, a bank of stage lights blazing down on Bernhardt, activated by Tesla, but the heightened language and light were meant as a kind of duet, signaling a genuine question: Is it necessary, or possible, to sacrifice ego and intellect for love? (I lifted Sarah's lines, I vaguely recall, from a Robert Bly translation of Kabir.)

The question is wordlessly answered in the next shot, when Tesla, splashing water on his mortified face, gives himself a hard look in the mirror. It's one of my favorite shots in the movie—a moment of pitiless self-assessment. It echoes a similar shot in our *Hamlet*, when Hamlet/Hawke faces his reflection —in an airplane lavatory, no less—with an equally loaded look mixing self-contempt and resolve, after concluding: "My thoughts be bloody, or be nothing worth." Back to work, the doomed protagonist is telling himself, only half understanding that he's charging irreversibly off the cliff.

As Anne Morgan announces in the narration of my movie, Sarah Bernhardt met Thomas Edison in December 1880, during her first visit to the US (four years ahead of Tesla's arrival in New York). Bernhardt devoted half a chapter to the tête-à-tête in her 1887 memoir, *My Double Life*, describing in dramatic detail how she diverted her private train to look in on the Wizard's lab in Menlo Park, NY, arriving at 2 am during a mild snow storm and staying for two hours. Edison, an established night owl, received her warily, but she won him over. "His wonderful blue eyes," she wrote, "more luminous than his incandescent lamps, enabled me to read his mind." Edison provided a tour of thundering machinery and flashing lights, and Bernhardt recounts nearly fainting, all the while insisting on the pleasure of Edison's company: "He

explained everything to me. I understood it all, and I admired him more and more, for he was so simple and charming, this king of light."

As in my film, she recited Racine into Edison's phonograph, her voice recorded on a long-lost wax cylinder.

I invented the awkward backstage visit wherein Tesla meets Bernhardt and suffers a flash of jealousy when she strolls off with Edison and his new wife. The post-blackout scenes with Madame Sarah in Colorado Springs are also invented, though one of Bernhardt's farewell tours took her to that very town in 1905, six years after Tesla overloaded the local power station.

The one true, historically verifiable overlap between Bernhardt and Tesla occurred when the inventor attended a Fifth Avenue dinner party thrown for the actress in February 1896, a high-society soiree placing Tesla in contact with the Hindu spiritual leader Swami Vivekananda. Bernhardt wanted to meet the thirty-three-year-old swami, who had acquired a significant worldwide fame of his own, after spotting him in the audience while she was performing in *Izeyl*. We have this description of the play from Vivekananda himself, nestled in a letter to an English disciple:

> It is a sort of Frenchified life of Buddha, where a courtesan "Iziel" [sic] wants to seduce the Buddha, under the banyan —and the Buddha preaches to her the vanity of the world, whilst she is sitting all the time in Buddha's lap. However, all is well that ends well—the courtesan fails.

Swami Vivekananda in San Francisco, 1900.

She *dies*, in fact—Bernhardt was a specialist in dramatic deaths—in his arms, after having undergone a series of tortures, including having her eyes torn out.

If I had been more diligent in my research, and supplied with a bigger budget, I might have been tempted to import a scene from this charming stage production into my screenplay, though, as things stand, I can be accused of mirroring it in the movie, highlighting the hero's purity, or puritanism, by allowing a wanton woman to place herself in his path. My counterargument: I was interested in underlining Sarah Bernhardt's vulnerability and elusiveness, as much as her eroticism, echoing the portrait delivered in Julian Barnes's *Levels of Life*, a grief-haunted novel in which the actress personifies emotional risk, a bravery of spirit that transcends artifice and ego, sex and seduction, even as it develops from them. "You must not be angry with me," she tells a passionate, disappointed lover. "You must think of me as an incomplete person."

I was interested in understanding Tesla and Bernhardt as two mutually incomplete people.

As the *New York Herald* reports, the "feast" for the swami accommodated a three-way discussion between "the tragedienne [Bernhardt], the professor [Tesla] and the Brahman [Vivekananda]" during which they discussed "the great question of life and death and the great hereafter," trading "exquisite but contradictory theories of life and morals." I wish history had provided us with a transcript. Lacking further details, I drafted, and abandoned, scenes in which Tesla and his new friends argue about the transmigration of souls,

Rebecca Dayan as Sarah Bernhardt in *Tesla*.

the nature of the divine, the eternal, and the best dietary formulae for sustaining a spiritual existence. But these interactions, I concluded, belonged in a different movie. Tesla and the swami, in any case, hit it off well enough to meet at least once more and to exchange letters after Vivekananda enlisted "the great electrician" to translate precepts of vedantic philosophy into the slightly less mystical realm of pure mathematics. It's my understanding that Tesla never quite pulled this off, though he shared with the swami an investment in the concept of an all-encompassing cosmic ether—a notion effectively obliterated once Einstein stepped on the world stage. (Prescient as he may have been regarding other realms of physics, Tesla refused to accept Einstein's relativity theory—"The idea that mass is converted into energy is rank nonsense"—and claimed cosmic rays and radio waves could travel faster than light. Unravelling late in life, he continued to believe in an all-pervasive ether while calling out Einstein, in an unpublished poem, as "a long haired crank.")

I reduced the Vivekenanda–Tesla relationship to a single scene, compressing the swami's dialogue into one calmly assertive block:

> Chastity is a path to enlightenment. A great inventor should
> never marry. You realize this . . . We are what our thoughts
> have made us. So take care about what you think. Thoughts
> live. They travel far.

I'm inclined to believe the last four sentences, unscientific as they may be. Tesla, in the film, gives his assent, but he's distracted, standing before a knock-off of Michelangelo's *Battle of Cascina*, in which a group of bathing soldiers twist their torsos in alarm as they confront a surprise attack. I suspected this

explicit stage whisper, directed at the question of Tesla's sexuality, might be too presumptuous and emphatic, and that its intrusiveness would trigger complaints, but to my knowledge no one has taken offense, or even noticed it.

Vivekananda, I learned only recently, was one of the revered predecessors of Swami Prabhavananda, the subject of Christopher Isherwood's *My Guru and His Disciple*, a candid, often comic memoir of spiritual apprenticeship in Los Angeles during WWII. Though he died in 1902, at age 39, Vivekananda's name bobs up throughout Isherwood's book and at one point, while admitting a weakening of his faith, Isherwood, the unsteady acolyte, sifts through Vivekananda's posthumously published journals and notebooks and shares this quote:

> I hate this world, this dream, this horrible nightmare, with its churches and chicaneries, its fair faces and false hearts, its howling righteousness on the surface and utter hollowness beneath, and, above all, its sanctified shop- keeping.

It's bracing to be reminded that world-famous spiritual instructors are not necessarily complacent, or blind to the contradictions of their calling. There's nothing quaint or easy about the attempt to occupy a higher reality. I wish I'd read these words earlier, and fed them into the film—if only to spark a response from Tesla, whose private grievances weren't nearly so corrosive or self-revealing.

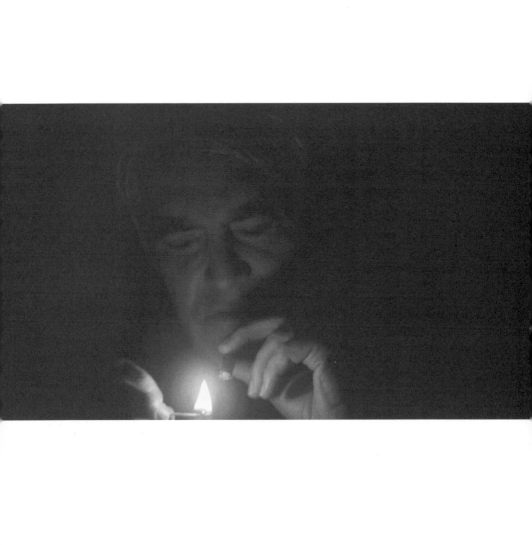

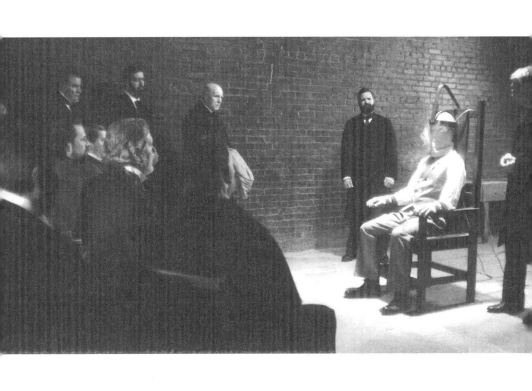

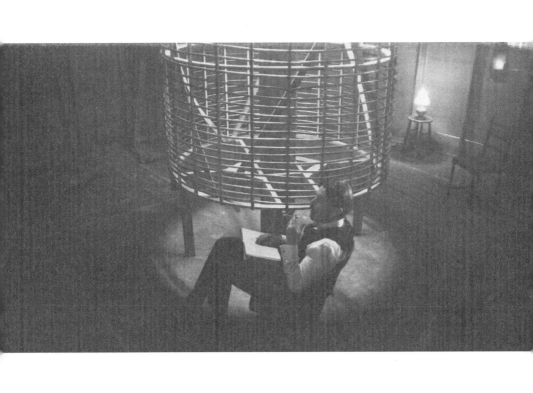

11 CONVERSATION IN THE LOBBY: WORLD WIRELESS ENERGY

A. S. Hamrah interviews Michael Almereyda
(Slightly abridged and adjusted from *The Baffler*, August 17, 2020)

I wanted to review Michael Almereyda's Tesla *but the film's distributor only allows web links for press screenings, and I don't think it's fair to filmmakers to write about their movies if I can only see them on my computer. Averse to Vimeo, they offered to send me a DVD screener, but it never arrived. So instead I decided to try to talk with Almereyda, who I'd never met, even though I hadn't seen* Tesla. *These days it's easier to speak with directors than to see their films, so good for the film industry for figuring that one out.*

A. S. Hamrah: Congratulations on *Tesla*, a film I understand you've been trying to make for some time. How were you able to finally make it now?

Michael Almereyda: Two producers behind my last two features offered the project to people connected to Millennium Media, after having been rejected by every other company they'd approached. Millennium's willingness to finance the film centered on Ethan Hawke's attachment. Which doesn't

lessen my gratitude, but it was really that simple. They liked the idea of making an Ethan Hawke movie, at a price, and that movie happened to be about Nikola Tesla, written and directed by me.

ASH: Do you think Nikola Tesla speaks to the present in a way he didn't at the time you first conceived the project? Tesla seems to me, without having seen the film, a symbol of thwarted hope for a better world.

MA: It's true that an awareness of Tesla has expanded in the last forty years, given the existence of various books, a postage stamp, and a particular tech company that manufactures electric cars and space rockets. But Tesla was always a loner, an aggrieved outsider, a voice in the wilderness. He embodies a kind of yearning that was always at the core of the story for me.

To really answer your question, we're now living in a world informed and transformed by the internet, which Tesla was anticipating and forecasting in the 1890s, even if he fell short of achieving the specific breakthroughs that made the internet possible. So it's vaguely possible a larger audience, in 2020, might be receptive to a story about this difficult, disappointed visionary.

What's your perception of Tesla, untainted by this movie? Have you read any books by or about him?

ASH: I've never read a book about him. In addition to learning somewhere along the way that he was interested in developing wireless communication, I knew he invented alternating current, that he developed a death ray of some sort, that he was friends with Mark Twain and that he and Edison were

Tesla with his oscillating transformer, aka a Tesla coil, in his lab on East Houston Street, New York. Photograph by Tonnele and Company, 1896.

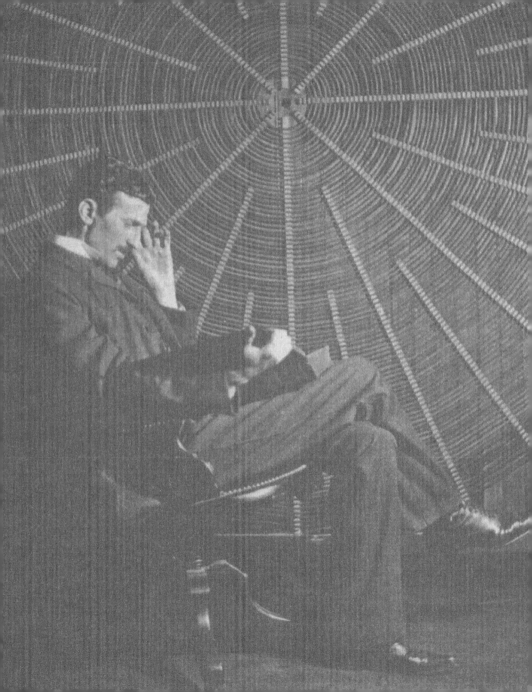

bitter rivals. I knew he died poor and alone in a hotel in New York after a long life. And I know David Bowie played him in a movie I haven't seen, and that there's a song from the 1980s called "Tesla Girls." Didn't Tesla want to provide the world with free electricity?

MA: He strove to develop a system of worldwide wireless energy and spent a good deal of effort promoting it without coming up with practical results. Years after his death, scientists and engineers intent on following his tracks, fulfilling this dream, have concluded that Tesla was misguided or even delusional. As my research stretched over many years, I came to realize the phrase *free energy* was attached to Tesla's project by other people, though he never presented it as such. That said, his theories and projections set him on a collision course with embedded technology and the people who profit by it, so that conflict is part of the story.

ASH: Since I haven't seen the film, could you tell me what it looks like?

MA: I just attended the film's premiere screening in Queens, a drive-in screening where I was allowed to get out of the car and watch from a grassy knoll—is there any other kind?—with a hand-held radio playing the movie's soundtrack against the thrashing of highway traffic. I can report that the film looks notably *dark.*

ASH: You mean the print, or the DCP, is too dark? Or the photography is darker than you expected? Or that the film creates a sense of overall darkness, a dark mood?

Tesla premieres at the Queens Drive-In, August 13, 2020. Photograph by Michael Almereyda.

MA: The darkness was intended, atmospheric, aimed to make colors smolder, but watching from afar can require serious squinting. The screen, though thirty-six feet tall, was like an aquarium set within a vaster, open-air aquarium with about 180 cars arranged before it like a fleet of paralyzed fish. Occasionally, someone's red brake light would flash on and off, and it was hard for my eyes not to stray to the competing purple glow of the newly renovated Science Center, lit up for the occasion. No telling what people were doing or feeling inside those various vehicles, but afterwards a few drivers honked with approval. They made a nice din.

ASH: Before you shot the film, how did you arrive at this darkness you mention?

MA: Sean Williams, the film's cinematographer, and I were considering obvious questions about light sources, natural light and candlelight compared to gas and electric light. When I visited Sean in London a month before the shoot commenced, there was a breathtaking show of Bonnard paintings at the Tate Modern. I went twice. Sean went at least three times. I'd like to think some of the feeling of Bonnard, if not explicit frames and colors, invaded our thinking about Tesla. We also paid close attention to Lartigue photographs, black-and-white and autochromes, Seurat drawings and paintings by Sargent, Manet, and Degas. We rewatched Derek Jarman's biopics, *Caravaggio* and *Wittgenstein*, and we were enthralled by an early, hallucinatory Sokurov film, *Stone.*

ASH: Those Jarman films certainly approach the biopic in unique ways, and in their lighting, too. I've never seen or even heard of *Stone.*

Edgar Degas, At the Milliner's, 1882.

MA: *Stone* is an oblique, or opaque, biopic, in black-and-white, shot with anamorphic lenses and projected without the usual corrections those lenses require, so the image is uniquely compressed and warped. One of the actors is meant to be playing Anton Chekhov, though he looks too old and sour to be Chekhov, who died at forty-four.

ASH: You've released *Tesla* into a world where it can't be shown in theaters. At least not in the United States. How do you think seeing it via streaming services affects viewers' reception of the film? And where can people see it when it's released next week?

MA: I was sent a list of over a hundred theaters that will screen the movie starting August 21, most of them in Utah, Ohio, Texas, and Florida. Five in Kansas, where I happen to hail from. The number is expanding by the day, astonishingly enough. Under normal conditions, I suspect far fewer venues would have embraced it. And IFC will also stream it far and wide.

ASH: That's an interesting development about all those theaters in those states. What do you think the future of theatrical exhibition will be after the pandemic?

MA: Daily reality feels so precarious, I can't see beyond next week, and I can't pretend to guess where we'll land in the near or far future. For now, I sympathize with anyone who loves movies, exiled from theaters.

ASH: You're the only person in the film industry to go on record with no predictions. Admirable.

MA: I also can't help noting that the laments of cinephiles can seem paltry compared to other life-and-death dangers and conflicts we're currently tumbling through. I've read your thoughts about the dismal non-alternatives to theatrical distribution, and I don't disagree with you, but what, really, is to be done?

ASH: I don't agree that these are small problems we face in terms of moviegoing. The fight for justice and really for the future happens on screens as well as in the streets. After all, if NBC had not given Donald Trump a TV show in 2004, we wouldn't be in a situation half as terrible as the one we're in now. A too-easy acceptance of entertainment is part of what got us here. I think the cinema is important in countering the "everything is awesome" world of streaming entertainment that is only gaining traction since Covid. Your work, it seems to me, has always been a counter to that, in its originality and complexity and in the subject matter you choose. And it's best seen on a large screen without interruption. And *Tesla* is finished and about to come out. But I have to be able to see films in order to write about them and get paid. If that's paltry I guess it means that part of the chain doesn't matter.

MA: The chain you mention is both a supply chain and a circuit of power affecting the production and distribution of images, stories, and ideas, all blended together. Each link in the chain, each human component of it, is vital, all the more so at a time when what's flowing across the world's screens can seem homogenized, trivial, and toxic. Independent filmmakers are also beholden to this system, which resembles a factory more than a garden. How does any unique voice ring out amidst all the commercialized noise? And how do our voices carry the same conviction when we're exiled from the

experience of seeing movies as they're meant to be seen? So, okay, I concede these matters are hardly insignificant.

ASH: Speaking with you, I can't help but notice you exude a great sense of calm. How have you managed to stay so composed during the last six months of constant crisis in American life? I can imagine releasing a new film under current circumstances is a difficult undertaking.

MA: I've never made a film that's been widely distributed, marketed full-force with TV ads, subway posters, thousands of prints hitting thousands of screens. Yet I've always had it in mind to project even the smallest of my films and videos on a big screen, available to groups of friends and strangers in a darkened room. That's always felt basic, inviolable. So I'll circle back to your earlier question and register a wish rather than a prediction, that the current crisis will pass, or change shape to the degree that people will continue to rendezvous in the dark, experiencing films in theaters throughout the world.

This is a roundabout way of saying I don't feel remotely calm. I recently came across a clip of an interview with Pasolini, a true rebel who was also, not incidentally, committed to spiritual ideas. He responds sharply when asked about the consolation of the Gospels. "I'm not looking for consolation," he says. "Like any human being, I look for some small delight or satisfaction, but consolation is always rhetorical, insincere, unreal. Consolation is a word like hope." The clip cuts out there, regrettably. I would've liked to hear Pasolini describe a decent alternative for consolation and hope.

How are you navigating this storm?

Edison's Vitascope, eclipsing his single-viewer Kinetoscope, first screened short films for a paying public at Koster and Bial's Music Hall in New York's Herald Square, April 1896.

EDISON'S GREATEST MARVEL

THE VITASCOPE

"Wonderful is The Vitascope. Pictures life size
and full of color. Makes a thrilling show."
NEW YORK HERALD, April 24, '96.

ASH: I'm navigating it in near isolation and inadequate air-conditioning, in close proximity to the BQE. My consciousness is eroding and my economic precarity is increasing.

MA: I don't know anyone who's stayed in the city without feeling drained and frayed. I want to imagine there can be a sense of solidarity in the uncertainty, but I don't see much evidence of it in the streets right now, even after the protests, or even in my apartment building. We may need air-conditioning, but there's a cold wind blowing.

12 THE SECRET OF NIKOLA TESLA

*There is no passion for the absolute without the
accompanying frenzy of the absolute.*
—Louis Aragon

There is, actually, one pre-existing, full-on Tesla movie preceding mine, a
quaintly flatfooted biopic made in English in the former Yugoslavia, cast
with mostly European actors: *The Secret of Nikola Tesla*, released in 1980,
the year I landed in New York after dropping out of college. I remember
feeling nettled by the fact of the film's existence—but did it even have a North
American release? Somehow I found my way to a private screening at the
Yugoslavian embassy, a mansion on upper Fifth Avenue, formerly occupied
by a Vanderbilt. The majestic venue offset the movie's comical clunkiness,
the stiff, airless, under-scaled nature of the entire production, the dubbed
voices—or did they all just *sound* dubbed?—and the starkly miserable Ed
Wood level of the "special effects."

On revisiting the film—you can see it on YouTube, courtesy of a service called UFO TV—it doesn't seem quite as impoverished as I remember. I suspect the director, Krsto Papić, had more resources than were available for my *Tesla*—money or manpower enough to stage a plausible nineteenth century ditch-digging scene on a paved city street, for instance, and lumber enough to build a significantly storied scaffolding to stand in for Tesla's Wardenclyffe tower. Tesla is played by Petar Božović, a dolorous Serb with a more than decent resemblance to the real person. He has an ascetic face, a long nose, wounded eyes; he's fittingly wan, spare, remote. He gives our unfortunate hero a plaintive dignity, projecting injured pride and an unshakable shyness. But nearly every square inch of his dialogue is embarrassing.

"I am not an inventor," Tesla tells J. P. Morgan, "I am a discoverer." At the height of his glory, celebrating the inauguration of the power station at Niagara Falls, he reluctantly receives a round of applause, then addresses the banquet crowd with pedantic joylessness: "The real work is yet to come . . . Now we must liberate thought. We must set it free of limitations that space and time impose on it and yet keep its characteristics, now and in future centuries, here on earth and thousands of light years into the unknown. Excuse me, I—"

He falters and blinks, as if such visionary imaginings have made him dizzy, and "haunting" organ chords propel him from the stage. But the dialogue gives only a dim approximation of the language unleashed in Tesla's actual lectures:

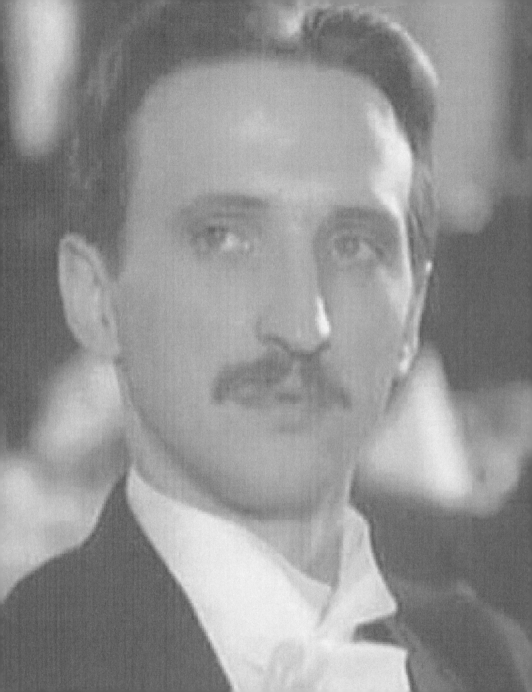

There must be some way of availing ourselves of this energy more directly. Then, with the light obtained from the medium, with the power derived from it, with every form of energy obtained without effort, from the store forever inexhaustible, humanity will advance with giant strides. The mere contemplation of these magnificent possibilities expands our minds, strengthens our hopes and fills our hearts with supreme delight.

It was tempting, early on, to jigsaw these prophecies into my screenplay, particularly when they become apocalyptic:

Modern science says: "The sun is the past, the earth is the present, the moon is the future." From an incandescent mass we have originated, and into a frozen mass we shall turn. Merciless is the law of nature, and rapidly and irresistibly we are drawn to our doom.

Paul Auster inserted the sun-earth-moon axiom, a quote within a quote, in a fortune cookie in his 1989 novel, *Moon Palace*, and a fortune cookie may well be the best place for it, though the full passage gives you fuller evidence of Tesla's metaphysical striving, his desire to earn and claim superhuman knowledge of nature's protean, unpredictable "law." In yet other statements —and there are plenty—you see his ongoing hunger for transcendence, an insistence that the mastery of nature is within human reach and he's just the man for the job. But by the time I was refining the shooting script, I'd developed an aversion to Tesla's aspirational musings and found cause to trim or jettison them. How much visionary verbiage can a movie bear? A

Petar Božović in *The Secret of Nikola Tesla* (1980).

little, I figured, would go a long way, and this conclusion fed into the film's visual style, which was intended to frame and counterbalance the self-mythologizing nature of Tesla's utterances and temperament, to illuminate his shuttered inner life, and, as Aragon would have it, his passion for the absolute.

What, I asked, if this passion, aligned with Tesla's feverish heightened consciousness, could be both matched and undermined by the movie's visual language? What if rear-screen projections, lush lighting mixed with flat backgrounds, could approximate this level of extravagance and abstraction, allowing for flashes of fantasy and time travel? What if literal-minded naturalism simply gets thrown out the window, to accommodate another kind of imagery and feeling? What if my Tesla movie went more distinctly, more assertively, out of its mind?

13 MYSTIFICATION

Over the years, I had become resigned to the idea that I'd never make my Tesla movie. A science-fiction film set in the late nineteenth century—what could be more expensive, more outlandish, more out of reach?

There were rumors and reports, spanning decades, of Tesla films in development, including concrete projects by Dušan Makavajev, Julie Taymor, and Jim Jarmusch—and I was more than a little curious about them, receptive from a reasonably envious distance. None of these materialized. But in 2006 Christopher Nolan delivered *The Prestige*, inserting Tesla as a sorcerer-for-hire, a suitably unlikely deus ex machina, in a feud between two Victorian magicians. In casting David Bowie—yes, of course, *Bowie*— as Tesla, Nolan unapologetically pitched the story into the realm of pop mythology, enlisting the iconic man out of time to play an iconic man out of time, the inventor of a trapezoidal box that teleports matter (first top hats, then magicians) when the torrid, gyrating plot requires it. Of course, just about everything Bowie/Tesla does and says in this movie is, you know,

invented, though Nolan's script (written with his brother Jonathan, based on Christopher Priest's novel) is familiar enough with historic fact to intercept Tesla during his photogenic researches amidst the mountains of Colorado Springs. "We do our tests when the townspeople are asleep," Tesla's henchman explains to Hugh Jackman one hazy blue night, while Jackman kneels over a wirelessly glowing incandescent bulb planted in prairie soil, surrounded by dozens of identically glowing bulbs stretching to the horizon. "Mr. Tesla doesn't want to scare anyone."

Tesla never accomplished this miracle, never created a resplendent field of wireless light, though he claimed he'd get to it, and the image is compelling, provocative, measured against Tesla's actual, eventual failure. The spectacle has no greater point in Nolan's movie than to set the stage for Bowie's impressive entrance when he welcomes Jackman to his lab, striding through a latticework of dancing CGI lightning. It's Bowie all right, but his Tesla seems almost disembodied and blank—a gentlemanly hologram, looking permanently vexed. We soon see him chased out of Colorado by Thomas Edison's "agents"—a complete fabrication—and this hasty departure prompts Tesla's tart, pseudo-philosophic note delivered in voice-over: "The truly extraordinary is not permitted in science and industry. Perhaps you'll find more luck in your field"—the field of outright magic—"where people are happy to be mystified."

Tesla shows up later in the tale, in Europe, comfortably "retired" (another fabrication), a world-weary mandarin who's nevertheless ready to grant technological aid to Jackman, since he, Tesla, understands the nature of obsession only too well.

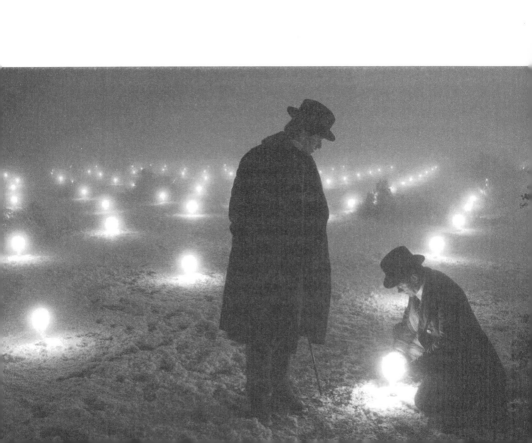

As if extrapolating from Arthur C. Clarke's axiom—*technology of the future is indistinguishable from magic*—Nolan presents Tesla as the ultimate magician, a nineteenth-century Mandrake, suave and impenetrable. The portrayal centers on sheer mystique, ignoring the inventor's actual agenda and personality. There's no place in *The Prestige* for Tesla's germaphobia, his haplessness with money, or the romanticism radiating from his public statements. Which may have been a fine approach, avoiding outright corniness, though it leaves Bowie dangling, tasked with playing a cipher, a sphinx.

But sure, of course, *this is a movie*, an admirably unclassifiable fabulation engineered to throw off sparks by mixing glowering Victorian archetypes with vaguely metaphysical notions concerning fate, illusion, and fanatical perfection of craft. Actorly gravitas, luxuriant production design, and state-of-the-art effects give the movie weight. Though it can also be argued that Nolan's characters, more than his plot devices and his sets, are like magicians' cabinets, equipped with false bottoms and trick compartments; the story is a contraption, all hinges, twists, and trap doors, and *The Prestige* turns out to be, above all else, a celebration of trickery. Though modest by Nolan's blockbuster metrics, the movie was a hit, grossing three times its $40 million budget—yes, people are happy to be mystified—while incidentally introducing Tesla's name and aura to a broader audience, just ahead of Elon Musk's worldwide branding. Tesla Motors manufactured their first completely electric Roadster in 2008, and the first car was sold in February of 2009, priced at $109,000.

Hugh Jackman (left) seeking illumination and revenge in Christopher Nolan's *The Prestige* (2006).

14 MR. TOMORROW

Bowie's impenetrable Tesla bears some resemblance to the inventor's extended cameo in Paul Auster's aforementioned *Moon Palace*, a picaresque tale concerned with the puzzle of identity, the savage changeability of fate, and the power of storytelling, though Auster is more generous towards his quixotic characters, and more committed to investigating their inner lives. Tesla enters the novel halfway through, with Auster serving up a brisk rundown of the inventor's initially dazzling career, described with cartoonish brio. Tesla—"this tall man dressed in a white tuxedo"—is a conjurer demonstrating wonders at the 1893 Chicago World's Fair. "He performed magic tricks with electricity, spinning little metal eggs around the table, shooting sparks out of his fingertips." The narrator is Thomas Effing, a

Tesla portrayed in the *New York Sunday World*, July 22, 1894, with this accompanying caption: "Nikola Tesla, showing the Inventor in the Effulgent Glory of Myriad Tongues of Electric Flame After He Has Saturated Himself with Electricity."

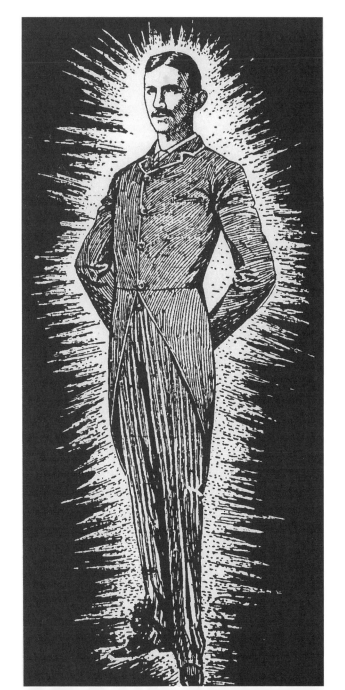

painter/adventurer, now in his eighties and confined to a wheelchair, recounting his personal history to the book's young protagonist, who's been recruited to write Effing's obituary. Tesla, we're told, "was like some prophet of the future age, and no one could resist him. The total conquest of nature! A world in which every dream was possible!"

Effing builds to a more direct Tesla sighting, when he's seventeen, living on Long Island while Tesla oversees the construction of his Wardenclyffe tower. Tesla and the teenager make eye contact, and there are consequences:

> I could feel his glance going through my eyes and out the back of my head, sizzling up the brain in my skull and turning it into a pile of ashes. For the first time in my life, I realized that I was nothing, absolutely nothing . . . once the shock began to wear off, I felt invigorated by it, as though I had managed to survive my own death. No, that's not it . . . When Tesla's eyes went through me, I experienced my first taste of death . . . I felt the taste of mortality in my mouth, and at that moment I understood that I was not going to live forever . . . I was seventeen years old, and all of the sudden, without the slightest flicker of a doubt, I understood that my life was my own, that it belonged to me and no one else.

And so a defining, existential message is conferred: "Tesla gave me my death, and at that moment I knew I was going to become a painter." Auster's assured prose makes the scene more convincing and complete than it might be in a movie, no matter how enhanced with special effects. And Auster, as deftly

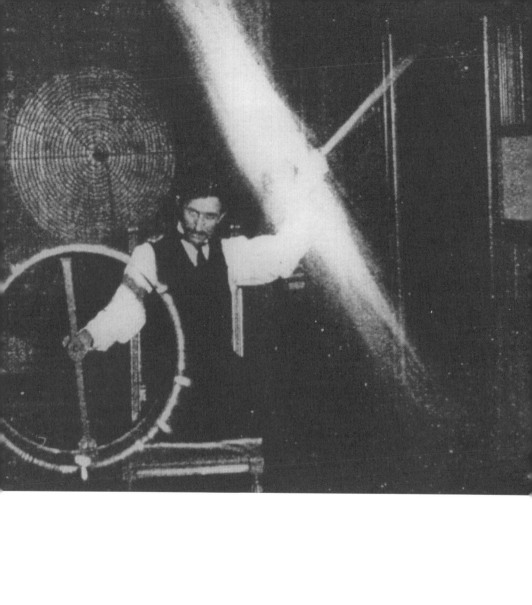

as Christopher Nolan, appreciates a twist, chasing the scene with a third encounter, tracking the arc of Tesla's downfall. Effing recalls crossing paths with the inventor decades later, when he's "spectral white, thin, as ugly to look at as I am now"—a defeated old man feeding pigeons in Bryant Park:

> He was standing up, and the birds were fluttering all around him, landing on his head and arms, dozens of cooing pigeons, shitting on his clothes and eating out of his hands, and the old man kept talking to them, calling the birds his darlings, his sweethearts, his angels . . . I wanted to laugh when I saw him. The one-time genius from outer space, the hero of my youth. He was nothing but a broken-down old man now, a bum . . . You're Nikola Tesla, I said, I used to know you. He smiled at me and made a little bow. I'm busy at the moment, he said, perhaps we can talk some other time.

With conscious cruelty, Effing presses Tesla to take a ten-dollar bill. "I could see him struggling . . . to tear his eyes away from the money—but he couldn't . . . I'll never forget the confusion in that son of a bitch's eyes. Mr. Tomorrow, the prophet of a new world."

In the space of seven pages, Auster illustrates a man's hopeful youth, a threshold moment in his adolescence, then his conclusive, bitter disillusionment through concise poster-bright descriptions of Nikola Tesla's rise and fall. Even more than in *The Prestige*, it's Tesla as talisman, mythic even as a pigeon-fouled failure. And here we brush up against a problem— possibly *the* problem—Ethan Hawke and I kept grappling with as we talked

through my Tesla screenplay: How can an actor play a genius, a mystery, a talismanic sphinx?

You can't, Ethan sensibly insisted, act "mysterious" or "brilliant" or "mythic." The challenge, the necessity, is to decipher Tesla as a human being, showing him out in the world among other people, acting and acted upon, even as it's a plain and potent fact that he was largely living in his head.

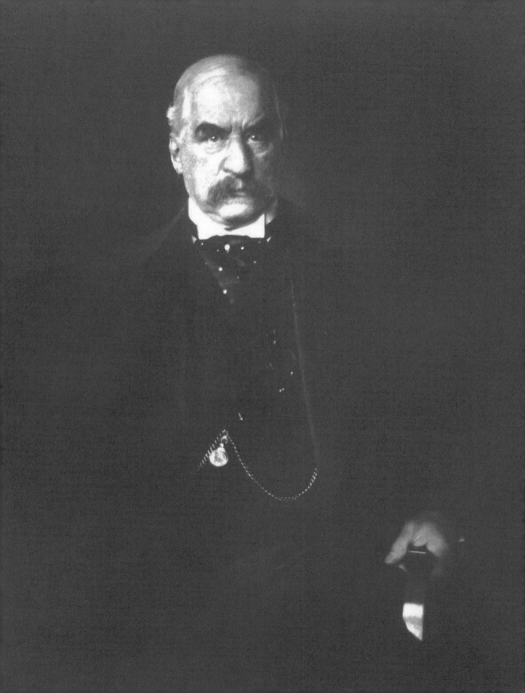

15 MORGAN'S NOSE

Orson Welles plays J. P. Morgan in *The Secret of Nikola Tesla*, and my early memory of the film is fixed mainly on his presence. It's one of Welles's more offhand performances, following his turn as the head of World Wide Studios in *The Muppet Movie* (1979) in which, installed behind a massive desk, he utters a single, momentous line: "Miss Tracy, prepare the standard Rich-and-Famous contract for Kermit the Frog and Company."

Welles seems to have expended less energy on his J. P. Morgan than he might have given a guest shot on *The Merv Griffin Show*, holding an identical cigar. His scenes—there are half a dozen, for which Welles received second billing under Bòzović—include a fanciful encounter that sets Morgan at the head of a long table, forcing contentious talk between a grouchy "Tom" Edison and a polite Tesla, the newly-summoned insurgent. Reading from a file on Tesla, the Commodore—Morgan's seafaring nickname—rattles through AC/DC exposition, prompting Edison to leave in a huff when he realizes his former benefactor intends to back Tesla's rival system. (This never happened, of course. The battle of the currents was over and done when Morgan chose to help fund Tesla's system for wireless energy.)

J. P. Morgan photographed by Edward Steichen, 1903.

Did Yugoslav-born Oja Kodar, who plays Katharine Johnson in the film, provide producers with a bridge to Welles, or did Welles leverage his involvement to grant her a role? (It's unfortunate that Oja and Orson do not share any scenes, and she's dubbed; the films Welles directed her in reveal an infinitely more commanding actress.) In any case, Welles's main job in the movie is to look up from papers and folders and utter impatient remarks meant to showcase Tesla's amazingness and to indict the financier as a callous capitalist. Morgan gives the sensitive visionary money and false hope, only to withdraw them soon after. This, in broad strokes, is true to the record, though the details are loopy and false. In their final exchanges, Morgan is doing business from bed, wearing a striped robe and thick-framed glasses circa 1979. "As long as I'm backing you," he grouses, "I can't afford to let the world think I'm associated with a nut." Morgan questions Tesla about "a Jew over in Germany" and an anguished Tesla warns against nuclear power, in a muddled warping of chronology, the history of physics, and the advent of Einstein's theories. "The world is at a crossroads right now," Tesla cautions. "Perhaps we can survive the poison but there will come a day when the sources of energy will dry up." The farseeing proto-environmentalist urges Morgan to invest in "clean power" extracted from the sea, wind, and sun. "We simply take what already exists and put it to our use in unlimited quantities ... Power will belong to everyone."

Morgan dismisses Tesla, cuts him loose, after concluding that such futuristic fantasies could cause the destruction of his financial empire—a theory Tesla fans have accepted and indulged for decades.

Orson Welles as Mr. Clay in *The Immortal Story* (1968).

"Supposing, just supposing, he isn't crazy," Morgan muses, still in bed, with a look smoldering into the far distance. "That man could turn the world upside down and stand it on its head."

In another film, under the guidance of another director, Welles's unquestionable cunning, authority, and fondness for cigars might have translated into a definitive portrait of the willful, world-conquering Morgan. For the full span of his career, Welles possessed a consummate ability to communicate the uninhibited egotism, charm and menace of entitled despots and demigods: Kane, Arkadin, Quinlan, Kafka's Advocate, Isak Dinesen's Mr. Clay. But these enthralling monsters were incubated in movies directed by Welles himself. My imagination luxuriates in conjecturing the film he might have made from Tesla's story that same year, a mash-up of his *Magnificent Ambersons* and *The Trial*, with Jeremy Irons as a taut-jawed, stork-like Tesla oppressed by increasingly incomprehensible obstacles, temptresses and ogres, unable to overcome his failure of self-awareness as the nineteenth century collapses into the 20th and the world's shadows close in on him.

J. P. Morgan, as I understand him, was not Tesla's nemesis; he was simply playing by his own imperious playbook, and that book's most basic rule involved trust. Tesla accepted Morgan's investment—a dispensation of over $1 million in contemporary currency—and overspent, misled his benefactor about how he was using the money, and asked for more. When Tesla's many letters to Morgan—unhinged lamentations, insulting harangues— found their way into recent biographies, I was thrown into unexpected sympathy with the heartless banker. As it happens, the scenes between Tesla and Morgan in my movie are among the few that survive intact from

my first draft. What I learned from relatively recent books—Jean Strouse's masterfully comprehensive *Morgan: American Financier* (1999) and Charles Molesworth's distinctly focused *The Capitalist and the Critic: J. P. Morgan, Roger Fry, and the Metropolitan Museum of Art* (2016)—got translated into Anne Morgan's scenes and episodes of narration; but the Tesla/Morgan faceoffs were written by a twenty-one-year-old extrapolating from *Prodigal Genius* and from Edward Steichen's famously vivid 1903 photograph showing a murderous Morgan glowering into the camera, his hand gripping a chair arm that gleams like a knife.

Morgan, anyone could conclude, was a fearsome man with a fire in his head. But I never pegged him as a villain—as the villain in this particular tale— because I'd also read *Ragtime*, E. L. Doctorow's justly acclaimed 1975 novel, wherein Morgan is one of the historical figures antically commingled with the author's fictional inventions. *Ragtime*'s J. P. Morgan, when I first met up with him, felt altogether compelling and convincing and my characterization greedily fed on Doctorow's DNA:

> Everywhere men deferred to him and women shamed themselves. He knew as no one else the cold and barren reaches of unlimited success . . . Only one thing served to remind Pierpont Morgan of his humanity and that was a chronic skin disease that had colonized his nose and made of it a strawberry of the award-winning giant type grown by California's wizard of horticulture Luther Burbank.

Doctorow identifies the banker's omnivorous acquisition of material riches —"The holds of his ships were filled with collections of paintings, rare manuscripts, first editions, jades, bronzes, autographs, tapestries, crystal"— and locates a spiritual hunger at the heart of it, an emptiness driving Morgan to a study of earlier civilizations. "He felt if there was something more than he knew, it lay in the past rather than in the present, of whose total bankruptcy of existence he was confident."

Doctorow's Morgan set his sights on Ancient Egypt, as did the real Morgan, but the *Ragtime* version is more susceptible to mysticism: "In the clear blue light of the moon he heard from a native guide of the wisdom given to the great Osiris that there is a sacred tribe of heroes, a colony from the gods who are regularly born in every age to assist mankind."

And so I sketched Morgan in the screenplay: an unchallengeable, disconsolate, flesh-and-blood multi-millionaire with a diseased nose; a conqueror who has everything yet wants more; an insatiable searcher looking for solace in the changeless mysteries of ancient Egypt. This man, I figured, could address Nikola Tesla on equal ground, or at least match his rhetoric.

I lifted lines from William Blake and gave them to Morgan when he definitively deflects the broken inventor:

> Do not let yourself be intimidated by the horror of the world. Everything is ordered and correct and must fulfil its destiny in order to attain perfection.

Donnie Keshawarz as J. P. Morgan in *Tesla*.

These words have haunted me for decades, my scorn for them matched by a suspicion they might be true. Googling them to pin down the precise source, I was led to remember they weren't written by Blake but by Max Beckmann, recounting a dream in which Blake—"noble emanation of English genius"— visited him in his sleep. After which, Beckmann adds:

> I awoke and found myself in Holland in the midst of a boundless world turmoil. But my belief in the final release and absolution of all things, whether they please or torment, was newly strengthened. Peacefully I laid my head among the pillows . . . to sleep, and dream, again.

Beckmann confided this dream in a lecture, "On My Painting," in London in 1938, after having fled Germany the year before, joining his wife in Amsterdam when "the horror of the world" was raging at close hand, all-devouring.

In my original draft, J. P. Morgan delivered the Blake/Beckmann lines to Tesla in Morgan's study. A red-nosed man seated at a Renaissance-style desk with lion's paw feet, flanked by walls sheeted with red Italian silk damask. When it came time, at last, to shoot the movie, a casual inquiry revealed that the Morgan Library would consider letting us into the room for a minimum of $20,000. I transferred the scene to a tennis court, and inserted Anne Morgan and a female friend impatiently standing by.

Everything is ordered and correct and must fulfill its destiny . . .

Emma O'Connor and Eve Hewson in *Tesla*.

16 ORBITS

Throughout the shoot, sporadically, but sometimes in a torrent, Ethan Hawke sent me iPhone videos of himself reciting sentences in the low hissing voice of Nikola Tesla. These were sometimes direct Tesla quotations taken from books or the internet, or they were loose variations of such quotes, or they were improvisations channeling Tesla's spirit and Ethan's intuitions, mingling electromagnetism and Buddhist mindfulness into a cosmic overview.

> *We exist in relationship. All of creation exists in a kind of radical relationship: ecosystems, orbits, cycles, circulatory systems . . . To the Western mind "relationship" is a second-tier word.*

And:

> *The great struggle for any individual is the same as the great struggle of a nation, of a populace, of the world, which is the elimination of egoism. It's the great lie. Like one blade of grass screaming from the field: "Me. Me. ME! I am important." Yes, you are important. Just like everyone else.*

Some quotes were offered up more than once, and I fastened onto a true Tesla declaration I hadn't noticed before, and managed to insert it in a patch of voice-over when the ever-hopeful inventor writes a letter to Anne Morgan, hitting an optimistic high:

> *Every human being is an engine geared to the wheelwork of the universe.*

I wasn't sure of the precise context it sprang from, but the line confirmed Tesla's (and Hawke's) faith in circles, cycles, spheres and coils—the inter-connectedness of all things.

Ethan's videos were often shot with a filter, in flickering black and white evoking old movies, and he was half-in and half-out of character, wearing contemporary glasses and T-shirts, stationed in a curtained cubicle between takes (the production couldn't afford trailers or dressing rooms) or back home in a book-filled room. The videos were often silly and funny. They included backstage views of fellow cast members leering and smirking at the camera, flipping him the finger. I was usually dead tired when I watched them, at the far end of long days, and they struck me as energetic diversions, the inspirations of a man semi-trapped in Tesla's head, waving a rag from a

Josh Hamilton as Robert Underwood Johnson. From iPhone footage shot by Ethan Hawke.

high window. I was slow to realize he was feeding me script notes, prods and jabs for making the movie more personal. Reviewing Ethan's transmissions more than a year later, with time to attend to them more selectively, I can belatedly appreciate an element of righteous anger regarding Tesla's place within a secular wheelwork, as the commercial mechanisms of the Gilded Age are echoed with renewed force by the grinding gears of contemporary capitalism.

> *The rich are always extremely terrified of circles. They prefer a pyramid-like hierarchy. Keep everyone in their place. But the universe runs in circles. The truth is a circle. The circle is our friend.*

> *Energy is shared. It runs in a circle, a spiral perhaps, but it's always there for everyone, all the time. The rich prefer pyramids, they prefer hierarchy. It makes you think that things are impossible. You worship the top of the pyramid, keep your eye there, without realizing that there's nothing at the top of the pyramid that doesn't exist at the bottom of the pyramid.*

In some fundamental sense these ideas were flowing through the film, and had been physicalized within its circular time frame, camera movements and set design, particularly in the staging of action in Tesla's experimental station in Colorado Springs.

This is the one set I insisted should be built in three dimensions, scaled and detailed as nearly as possible from a series of promotional photographs that have become iconic. Built to Tesla's specifications on a plot of open prairie

within view of Pike's Peak, the station's exterior was barn-like and church-like, made of unpainted pine planks, and the interior figured in my mind as a hallowed space, a stage for the performance of miracles. A single wide back window was boarded up when inquisitive children kept buzzing around outside, disturbing the inventor's concentration and violating his sense of privacy. (Where did these children come from? The lone distant neighboring building was the School for the Deaf. Tesla chasing deaf kids away from his lab? Another scene in another movie.)

The lab's wide central room featured an inner arena contained by a low circular wooden fence with electrodes fitted along evenly spaced slats, and this fence enclosed a tall circular wire cage, in which a Tesla coil was wrapped around a central wooden mast that extended up through the open ceiling, capped by a copper ball. Once you have a set like this, there are few filmmakers who wouldn't call upon a Steadicam operator and move the camera in circles.

Carl Sprague, our production designer, has a resume that includes two decades as art director or concept artist on Wes Anderson movies, which means he can whip up architecturally precise drawings very quickly and with supreme skill. I was also charmed by the fact that Carl's great-great-grandfather is Frank Sprague, an illustrious electrical engineer and inventor who, like Tesla, worked under Thomas Edison before finding his own path. (Sprague's employ under Edison preceded Tesla's by one year, and was almost as unsatisfying and brief. He went on to develop his own non-sparking electric motor and to apply it to the design of electric streetcar systems and high-rising electric elevators that outpaced hydraulic models.)

Above: Tesla in Colorado Springs, another multiple-exposure by Dickenson V. Alley, 1899.
Opposite: Cinematographer Sean Williams and crew on Carl Sprague's set, 2019.

We found an affordable sound stage in Gowanus, Brooklyn—affordable perhaps because the street was being torn to pieces by a construction team overhauling the sewage system. (Seismic jackhammering and savage heaving and pounding noises would sometimes interrupt our shoot.) We didn't have the budget to build the Colorado lab's complicated ceiling, retractable mast and ball—a miniaturized model was crafted for cutaways—and our lab was not quite life-sized, as the stage had thick columns spaced across its length, requiring Carl to diagonally wedge the set within those forced parameters; but it was true in its scale, its roughhewn details, its look of raw and arcane functionality.

Photographs taken inside the Colorado lab were the most seductive images drawing me into Tesla's mythology when I was first reading about him, and they remain fundamental to his mystique, even when viewers know that the most impressive of them (the photo used for the cover and frontispiece of this book, and the picture on the preceding page) are conjuring tricks, multiple exposures stage-managed by Tesla and Dickenson V. Alley, a young photographer imported from New York courtesy of *The Century Magazine*, where a handful of images (from sixty-eight glass-plate negatives) eventually appeared. Tesla, fitted to his chair, head lowered over a book, did not actually occupy space with the bristling sparks raging between two terminals, but the picture encapsulates the thrilling, surging power, the unpredictability and danger, that characterized the inventor's work in the summer, autumn and winter of 1899, and Tesla's nonchalant pose projects the idea that he was in his element, serene and at ease.

The images also underscore the degree to which Tesla was willing to embrace illusion in his promotional push to sell inadequately tested concepts, systems, "discoveries." All his dreams were not quite true.

W. Bernard Carlson's exceptionally lucid 2014 biography, *Tesla: Inventor of the Electrical Age*, tracks Tesla's scientific achievement in Colorado Springs with great thoroughness and clarity, acknowledging his partial breakthroughs and inconclusive results. He also slips in an unsettling side story I hadn't encountered elsewhere, describing how Tesla grew confidingly close with his twenty-five-year-old assistant, engineer Fritz Lowenstein, a Czech immigrant recruited from New York. The relationship suffered a rift, Carlson reports, when Tesla discovered letters to or from Lowenstein's fiancé, resulting in the engineer's sudden departure and replacement in September, when Tesla's complex secret experiments were still underway. Lowenstein remained loyal to Tesla, testifying on his behalf in the course of later patent litigation, but this anecdotal evidence of jealousy, pettiness and spite reveals a Tesla at odds with the cool customer planted in Dickenson Alley's photographs or gliding through my film. *Death in Venice* played out on the Colorado prairie, with lightning storms and the depthless sky substituting for the fatal allure of the sea—that's a movie I wouldn't mind seeing, but it wasn't where I chose to take the tale when it was within my grasp.

In Colorado, early on, Tesla also enlisted a fourteen-year-old local boy to help out in the lab, assist with construction, run errands. In a letter written in 1962, when he was seventy-seven, Richard Bartlett Gregg remembered Tesla as "tall and thin and nervous" and recalled how the inventor, displeased by some mistake, once called him "a little fool." In due time, the fool attended Harvard

University, studying science, then graduated from Harvard Law School. In 1925 he traveled to India to make contact with Mahatma Gandhi and spent the next three years in Gandhi's ashram, teaching, spinning, learning. He gathered principles of non-violent resistance into three books, most notably a compact foundational volume, *The Power of Non-Violence*, first published in 1934. Readers attesting to Gregg's influence include Aldous Huxley, Bayard Rustin, and Martin Luther King Jr., who wrote a brief foreword for the revised 1959 edition.

Wouldn't it be fantastic if this circuit of benevolent activism radiated outward from the boy's contact with Nikola Tesla during a formative summer in Colorado Springs? But such was not remotely the case. Gregg is referenced, sometimes namelessly, in a few Tesla biographies, but none trace his story beyond Tesla's orbit; I only discovered it courtesy of Joshuah Melnick, the young actor (though considerably older than fourteen) cast as Gregg in my movie. Josh dutifully tapped into Gregg's Wikipedia entry, wherein the selfsame person is identified as "a social philosopher" and Tesla goes unmentioned. Gregg's many books and accomplishments reflect a stirringly virtuous life, with his last years channeling a farseeing commitment to ecology and organic farming. He died in 1974, age eighty-nine.

But Gregg, in my movie, is just a diligent, wordless sidekick, awed by his employer's self-manufactured lightning. And Lowenstein is also reduced to dutiful silence, though, as portrayed by my Colorado-born friend David Weinberg (see page 145), the engineer projects a degree of preternatural calm in the face of vast voltages, in the lab and on the prairie. (David registered his

Life after Tesla: Richard Gregg with Mahatma Gandhi in Ahmedabad, India, circa 1927.

own wry report on his experience playing Lowenstein, and an assessment of Tesla's virtues and flaws, in "Nikola and Fritz," the July 8, 2020 episode of his podcast series *Welcome to LA.*)

Choosing to end the film in Tesla's Colorado sanctum was an easy imaginative leap. The lab, which Tesla had in fact abandoned, never returned to, becomes in the film a kind of waystation, a purgatory where Anne Morgan sits at a round table with a cat pawing at a pocket watch, waiting for Tesla to wake up. When he does, he's not really there; he's a puzzled phantom, impatient to get back to work, walking in a circle around his caged coil. He vanishes in a flare of light, and the camera intercepts Anne, coolly delivering a few last words.

17 NAMESAKE

JOE ROGAN: I had a dream once that there was a million Teslas—instead of like one Tesla there was a million Teslas. Not Tesla the car but Nikola . . . and that in his day there was like a million people like him who were radically innovative.

ELON MUSK: Wow.

JOE ROGAN: It was a weird dream, man. It was so strange . . . I've had it more than once.

ELON MUSK: It would result in a very rapid technology innovation, that's for sure.

—From *The Joe Rogan Experience* #1169, September 7, 2018

Tesla's suit on display in The Tesla Museum, Belgrade, Serbia.

"How does this guy just keep inventing shit?" Joe Rogan asks rhetorically, during his first encounter with Elon Musk, a two-and-a-half-hour podcast interview that triggered national headlines, and a brief decline in stock for Tesla, Inc., when Musk took a puff from a cigar laced with cannabis supplied by his encouraging host. Musk, like Tesla and Edison, qualifies as an authentic visionary. He has degrees in physics and economics, and has fused his exceedingly canny entrepreneurial skills with game-changing imagination, energy and will. Just ahead of describing his dream of multiple Nikolas, Rogan asks more directly, "Do you ever stop and think about your role in civilization?"

A patient look at the full YouTube link (universally viewed, as this book goes to press, over *fifty-two million* times) reveals that the two men, facing each other across a table outfitted with twin microphone setups, a Buddha figurine, and plenty of bottled water, were mostly drinking Old Camp whiskey and maintaining a level-headed conversation that's remarkable, in my view, for its tone of fanboy enthusiasm and good-natured guilelessness.

While struggling to make *Tesla*, I'd learned to shrug whenever people asked why I didn't get Elon Musk to fund the movie. Musk didn't name his company, I'd point out; he inherited the name from Tesla Motors' first CEO, Martin Eberhard, a former electrical engineer and a Nikola Tesla enthusiast, who was dining with his future wife, Carolyn, in Anaheim, CA—at Disneyland, in fact, in a restaurant inside the *Pirates of the Caribbean* ride—when he suggested naming his fledgling company after the brilliant, underappreciated inventor. Carolyn granted instant approval, after having heard Eberhard pitch alternate names over preceding months. And so, in the spring of 2003, an

impecunious, intransigent Serbian-American loner maverick became the fitting if unlikely Mickey Mouse mascot for a company that manufactures electric sports cars.

Musk entered the picture the next year, with an investment of $7.5 million. He contributed significantly to the car's design and the company's rising profile, and by 2008 he was the new CEO, having staged a boardroom coup, forcing Eberhard out. Although the original founder's departure involved a non-disparagement agreement, Eberhard recently commented on his ouster, at a discreet distance, during a 2019 visit to Delhi, when he talked to India's *Economic Times*: "It was the brick on the side of the head. I did not see it coming at all. I have learnt to distrust people a bit more."

Tesla Motors evolved, with breathtaking worldwide impact and notoriety, into Tesla, Inc., and Musk's other companies and side projects have proliferated and prospered, reflecting a work ethic and a global/cosmic ambition rivaling the extraordinary career paths taken by Edison, Tesla, and only a few other unique tech giants of their day. Plainly enough, Musk—multiply married, the father of six children, a sparklingly confident, charismatic man with a habit of success and an undeniable aptitude for branding and promotion—has more in common with Edison than with his company's self-contained, self-destructive namesake. In 2014, Musk pledged $1 million (contributed in yearly installments of $100,00.) to the Tesla Science Center at Wardenclyffe, an organization that aims to transform the site of Tesla's greatest failure into a learning center and museum; yet, in another YouTube link, you can catch Musk in a 2015 interview admitting his higher allegiance to Edison:

The reason it is called Tesla is because we use an AC induction motor, which is an architecture that Tesla developed, and the guy probably deserves a little more play than he gets in society. But on balance I'm a bigger fan of Edison than Tesla, because Edison brought his stuff to market and made those inventions accessible to the world, whereas Tesla didn't really do that.

Musk can be forgiven—at least, I forgive him—for failing to note that Tesla constantly tried to bring his stuff to market, as market forces continually got in his way. The bottom line is this: Elon Musk, ranked as I write this as the richest person in the world, values the concrete usefulness of inventions and ideas above their free-floating potential. He has embedded himself in the hard-edged, ready-or-not, commercialized world in a way that Tesla, steered by a mystical temperament and uneven luck, never could.

Another glaring reason why Tesla isn't a credible role model for Musk: Tesla was a solitary operator working with a skeleton crew or, at the height of his achievement, performing as an orchestra conductor for grand projects managed and financed by Westinghouse. He proved himself incapable of the kinds of leadership, trust and tact that collaboration requires. Edison, as a captain of industry, presided over tens of thousands of employees, rewarding most of them, it's true, with relatively low wages while resisting union protections. Without tumbling into all the disheartening details, we can acknowledge that Musk's record on this front is idealistic in theory but hardly flawless in practice, including as it does a 2019 legal wristslap for suppressing his workers' rights to unionize. The ruling was partly a reaction

From *Elon Musk and Joe Rogan get a cartoon* (2020)—a four minute Flashgitz animation directed by Tom Hinchliffe and Don Greger.

to a line issued within a string of hectic anti-union tweets, an implicit threat to withdraw employees' stock options if they formed a union. To further validate his stance, Musk delivered this fanciful assertion:

> US fought War of Independence to get *rid* of a 2 class system! Managers & workers should be equal with easy movement either way.

The dream of easy movement between management and labor is offered here as a self-evident "should" without apparent regard for routine reality, and with apparent disregard for how labor relationships are stratified, layered, webbed. In what utopia has the worker–management relationship been so binary and fluid? And how does harking back to the War of Independence address the complications that workers and unions are facing here and now?

Musk capped his sweeping statements with an unassailable conclusion: "Managing sucks btw. Hate doing it so much."

Throughout their meandering 2019 conversation, Rogan giggles a good deal while Musk seems on the brink of cracking up, his mouth puckering, his cheeks lifting as he smiles and bites back laughter. Musk confesses his love of *Spaceballs*, the 1987 Mel Brooks *Star Wars* parody, and he's wearing an Occupy Mars T-shirt, and I wonder if seeing *Total Recall* at an impressionable age could have fueled his mandate to terraform the Red Planet. In any case, Tesla-like attributes and undercurrents can be glimpsed within the goofy banter. "I don't think you'd necessarily want to be me," he offers. His mind, he adds, "is like a never-ending explosion."

"You're a weird person," Rogan notes—the nearest he comes to offering his guest a challenge. Musk shoots back: "I agree."

As the conversation winds down, Musk expresses the desire for a "future where we are a space-faring civilization and out there among the stars." He fuses this with a benign company credo, the wish "to make useful things . . . [and] make the future exciting, something to look forward to." They end on a note of outright sappiness, with Musk sounding both brittle and wistful:

> MUSK: Many people do not like humanity and consider it a blight but I do not . . . May sound corny, but love is the answer.
>
> ROGAN: It is the answer.
>
> MUSK: Wouldn't hurt to have more love in the world.
>
> ROGAN: How you gonna fix that? Have a new love machine you're working on?

This sweetness—whiskey-induced, as it may have been—seems to have receded over the last two years. In the thick of the pandemic, Musk broadcast his displeasure at the prospect of his profits being threatened by government lockdowns, and in July 2020 a succession of tart tweets hit a crescendo with Musk declaring "We will coup whoever we want! Deal with it."—reflecting his approval of the overthrow of democratically elected Bolivian president Evo Morales, who had resisted Musk's grab for lithium deposits in his country's mines.

So much for universal love.

Am I straying too far from my avowed subject? Perhaps. Tesla shared Musk's proclivity to talk about "humanity," aiming at nothing less than uplifting the race, but he almost never ventured into the definably muddy water of political engagement, government policy, public debate. And love, as I've said, was never part of his vocabulary.

> *It is not simple to be able to love calmly, to trust without ambivalence, to hope without self-mockery, to act courageously, to perform arduous tasks with unlimited resources of energy.*

I gave these words, from an atypically personal essay by Susan Sontag ("Trip to Hanoi," 1968), to Anne Morgan, trimming some phrases, beveling off the literary edges. I felt the need to push past mere wistfulness, to press Anne's case, to imagine her asking, for perhaps the first and only time, if Tesla could meet her halfway.

He deflects her, of course, can't meet her eyes.

Though he might have pretended to misunderstand, and to deliver a quote from Confucius, as the elusive, high-minded Sontag once did when asked to draw a self-portrait: "Each of us is meant to rescue the world."

What would Elon Musk say to that?

Tesla in his forties, date and photographer unknown.

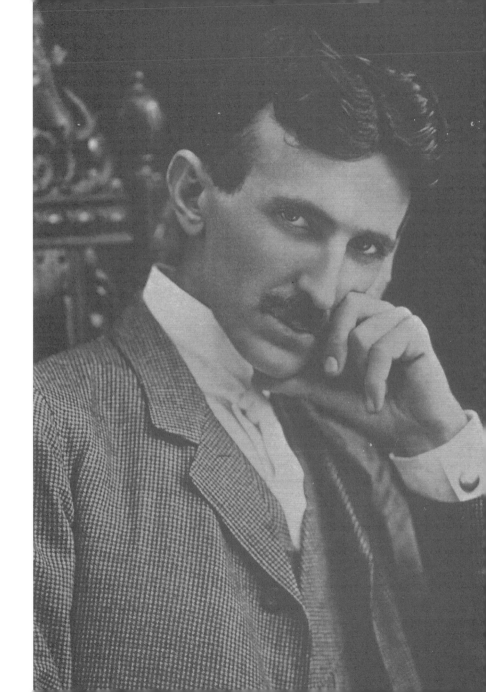

18 TESLA MEETS FRANKENSTEIN

There are reports that Tesla, late in life, enjoyed going to the movies, and in early drafts I gave him a brief scene in a Manhattan movie palace, seated apart from other viewers—formal, focused, and unreadable as a cat—watching *Bride of Frankenstein*, which was released in 1935, seven years before Tesla's death. It could have happened, Tesla taking in the *Bride*, though I'm guessing he was more likely to have caught the first *Frankenstein*, in 1931. Both films are beautifully directed by James Whale and both feature Tesla coils as dominant props discharging artificial lightning when the monster and his bride are, respectively, welcomed into the world. Whale, the preeminent gay Hollywood filmmaker of his generation, granted his monster nobility and even beauty. Boris Karloff's body and face, though lurching

Movie ads from the *New York Times*, January 8, 1943, six pages past the announcement of Tesla's death.

BROADWAY'S MOST COLORFUL HIT!

Maria Montez as Shera ... her name is on every man's lips ... her beauty is in every man's heart. You'll meet her in ...

WALTER WANGER'S

Arabian Nights
In Technicolor!

A Universal Picture starring

JON HALL · MARIA MONTEZ · SABU

with LEIF ERIKSON · BILLY GILBERT · Directed by John Rawlins

Rivoli

Popular priced performance of
ALFRED HITCHCOCK'S
"SHADOW of a DOUBT"
Starring Teresa Wright & Joseph Cotten with Macdonald Carey · Starts Wed., Jan. 13

BROADWAY & 49th ST. · POPULAR PRICES · CONTINUOUS PERFORMANCES

ALL R.K.O. THEATERS ARE HEATED BY COAL

BUY BONDS TODAY

RKO
MANHATTAN & BRONX

ALHAMBRA
CASTLE HILL
CHESTER
COLISEUM
81st STREET
86th STREET
FORDHAM
FRANKLIN
58th STREET
HAMILTON
MARBLE HILL
125th STREET
PELHAM
REGENT
RIVERSIDE
ROYAL
23rd STREET

[WESTCHESTER]
MT. VERNON
NEW ROCH.
WHITE PLAINS
YONKERS

BETTY GRABLE · JOHN PAYNE
CESAR ROMERO · CARMEN MIRANDA
HARRY JAMES & HIS MUSIC MAKERS

"SPRINGTIME IN THE ROCKIES" IN TECHNICOLOR!

THE WEIRDEST STORY EVER TOLD
plus AMAZING 2nd HIT!
"CAT PEOPLE"
DON'T BE SURPRISED AT ANYTHING YOU SEE!
SIMONE SIMON · KENT SMITH · JACK HOLT

GIFT TICKET BOOKS ON SALE AT ALL RKO — GOOD ALL YEAR 'ROUND!

BROOKLYN & QUEENS

BUSHWICK
DYKER
FLUSHING
GREENPOINT
KENMORE
MADISON
MIDWAY
ORPHEUM
PROSPECT
REPUBLIC
STRAND
RICH. HILL

The Impassioned Voyage of a Woman from Loneliness to Love!

BETTE DAVIS
PAUL HENREID in
'NOW, VOYAGER'

with
CLAUDE RAINS · BONITA GRANVILLE

LOEW'S TODAY'S MOVIE GUIDE

LOEW'S THEATRES ARE HEATED with COAL! Turn down your furnace and come to LOEW'S

STATE B'way & 45th St.
Hedy LAMARR · Walter PIDGEON
in M-G-M's 'WHITE CARGO'
On Stage GEORGE ABBOTT presents 'BEST FOOT FORWARD'
B'WAY MUSICAL COMEDY

MET. FULTON ST., B'KLYN Doors Open 10:30 A.M. Daily
FREDRIC MARCH · VERONICA LAKE
'I MARRIED A WITCH'
plus 'ONE OF OUR AIRCRAFT IS MISSING'
ERIC PORTMAN · GODFREY TEARLE
ONE OF YEAR'S 10 BEST — TIMES

PARADISE CONCOURSE, BX.
VALENCIA JAMAICA AVE.
LEXINGTON at the Circle
OLYMPIA B'WAY & 107th ST.
ZIEGFELD
72nd STREET 3rd AVE.
83rd STREET 3rd AVENUE
175th STREET 4th & BROADWAY

Meet TONDELAYO...
ravishing temptress of the tropics! She's fickle, flirtatious and dangerous! Men kisses drive men to madness!
Hedy LAMARR · Walter PIDGEON
in M-G-M's EXCITING ROMANCE
WHITE CARGO
plus 'ABOUT FACE'
WILLIAM TRACY
HAL ROACH'S FEATURE COMEDY

MANHATTAN
42nd STREET
116th STREET
COMMODORE
DELANCEY
INWOOD
MAYFAIR
ORPHEUM
RIO
SHERIDAN
VICTORIA

ALL-LAUGH SHOW!
ABBOTT & COSTELLO
"WHO DONE IT?"
plus THE RITZ BROS.
"BEHIND THE 8-BALL"

BROOKLYN
KINGS · PITKIN
GREENE
TRIBORO
WESTCHESTER
MT. VERNON
NEW ROCH.
WE. PLAINS
YONKERS

EILEEN COULD BE A SISTER TO ME!

MANHATTAN
4th STREET
ALPINE
BEDFORD
BROADWAY
CONEY IS.
GATES
KAMEO
ORIENTAL
PREMIER

BRONX
AMERICAN
BOULEVARD
BURLAND
BURNSIDE

JUST A LONELY GAL IN GREENWICH VILLAGE

Rosalind RUSSELL
BRIAN AHERNE · Janet BLAIR
MY SISTER EILEEN
plus 'COUNTER-ESPIONAGE'
WARREN WILLIAM

BRONX
16th STREET
FAIRMOUNT
GRAND
NATIONAL
POST ROAD
MANHATTAN
CANAL
LINCOLN SQ.
BROOKLYN
HILLSIDE
PLAZA
PROSPECT
WILLARD
WOODSIDE

HELD OVER!
HERE'S THAT HIT SHOW!

JERSEY CITY
'FOR ME AND MY GAL'
'ENEMY AGENTS MEET ELLERY QUEEN'

NO. BERGEN EMBASSY
'THE GLASS KEY' — Veronica Lake
'BEHIND THE 8-BALL' — THE RITZ BROS.

NEWARK
STATE

AVENUE B and 5th STREET
BREVOORT BEDFORD AV.
CENTURY NOSTRAND AVE.
ELSMERE

Fred MacMURRAY · Paulette GODDARD
'The FOREST RANGERS' IN TECHNICOLOR
plus DASHIELL HAMMETT'S
'THE GLASS KEY'
VERONICA LAKE · BRIAN DONLEVY

MELBA
LIVINGSTON ST.
VICTORY
13th ST. & 3rd AVE.
WARWICK

BAY RIDGE 3rd AVE. & 95th ST.
88th STREET 3rd & MADISON AVES.
APOLLO DELANCEY STREET

'FLYING TIGERS' and 'STREET OF CHANCE'
BETTE DAVIS 'NOW, VOYAGER' plus 'THE GREAT GILDERSLEEVE'

PALACE NEW YORK
DYCKMAN 207th STREET
SPOONER SO. BLVD. & 163rd

BOSTON RD. & STEBBINS AVE.
BORO PARK 46th STREET AND 13th AVE.

'THE MOON AND SIXPENCE' and SEVEN SWEETHEARTS' — Kathryn Grayson
'ONCE UPON A HONEYMOON' — Ginger Rogers and 'TIME TO KILL' — Lloyd Nolan

VODVIL TONITE!

Buy ANOTHER BOND TODAY! ON SALE at LOEW'S!

and scarred, project shyness and yearning; he's enduringly sympathetic. And while you can say Tesla has a more direct connection to Colin Clive's obsessive doctor, there's something decidedly Karloffian about Tesla, a deeper affinity as well as a physical resemblance. I'm thinking of Tesla's heavy-footed height, his unremediable outsider status, his aloneness. I imagined cutting between Tesla and the flashing laboratory equipment and shots of Elsa Lanchester's jerking head, her black birdlike eyes seeing Karloff's face, her angular recoil. When she opens her mouth and screams, would Tesla flinch or laugh? The unspoken theme of our film, I once told Ethan, is unrequited love.

In the script's next scene, walking back to his hotel, Tesla is struck by a taxi and knocked to the ground. He snaps to his feet, says he's all right, despite a broken rib. (This happened, according to O'Neill's book.)

Both scenes were jettisoned before they were shot. Our budget allowed only so many sets, locations, and stunts, and the price for excerpting *Bride of Frankenstein* would've been undoubtedly steep. Besides, it's fair to ask if the movie, riding into its final stretch, really needed an extra layer of subtext and pathos.

Colin Clive, Elsa Lanchester, Boris Karloff, and Ernest Thesiger in *Bride of Frankenstein* (1935).

19 LARGESSE

Short of skipping the subject altogether, it's hard for me to grant sympathetic attention to *The Current War,* a movie that escaped the death grip of Harvey Weinstein, its producer/financier, in 2017, and was released in the fall of 2019 after its beleaguered director, Alfonso Gomez-Rejon, managed to reshoot and recut the film as he saw fit.

Speaking as one punch-drunk filmmaker to another, I can salute Gomez-Rejon for his fortitude, but the single aspect of *The Current War* that strikes me as poignant is the fact that it presents Nikola Tesla in a lavish Hollywood production at long last, only to sideline him within his own historic moment.

Ethan Hawke with Jim Gaffigan as George Westinghouse in *Tesla*.

Played by Nicholas Hault as a baby-faced, arrogant supergeek, Tesla glides through just a handful of scenes, since the movie's irredeemable script focuses on the rivalry between Edison and George Westinghouse, with the latter presented as a paragon of virtue and valor.

As Anne Morgan gushes in my film's narration, Westinghouse was a gifted engineer and inventor as well as a supremely resourceful industrialist. Born a year ahead of Edison, he accomplished prodigious things at an early age, avoided personal publicity and, most accounts agree, was an exceptionally fair-minded and generous businessman, the first corporate manager in the US to institute a nine-hour work day, also offering pension plans to employees and installing on-site doctors and nurses to give injured workers immediate care during emergencies—a practice that implies emergencies may have been all too common. Over the years, Westinghouse plants included small hospitals to serve workers and their families, even when circumstances were less dire, and I could rattle through other benevolent Westinghouse innovations regarding wages, housing, insurance.

I'm sentimental enough to confirm my high opinion of Westinghouse by choosing to believe a story recounted decades after his death, by a witness on the scene during a particular lunch break, when a newly hired young immigrant, moving a heavily loaded wheelbarrow across rain-slicked planks, lost his footing and spilled everything into a muddy puddle. This was greeted with jeers and laughs from the man's co-workers—but Westinghouse himself happened to be present and, without a word, removed his gloves and stepped into the water and mud and helped the man reload the wheelbarrow. Then the boss turned without a word and went on into his plant.

Westinghouse and Tesla in "Prophet of Science," a six-page Tesla biography in *Real Heroes Comics*, 1946.

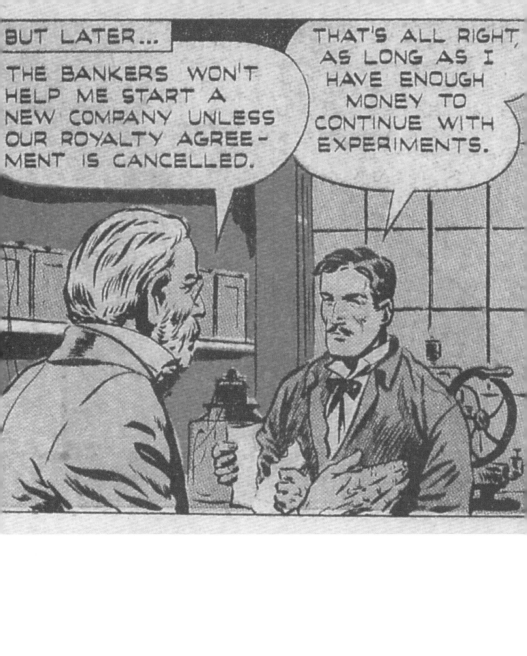

Westinghouse purchased Tesla's AC patents at a high price, recognizing them as a solution to the technological puzzle he'd staked his company's future on, and he outmaneuvered the slanders, electrocutions and legal obstacles sponsored by Edison, to successfully translate Tesla's ideas into practical reality, the system that became the world's prevailing mode for generating energy and light. In turn, Tesla maintained faith in Westinghouse as his eternal friend and ally, even when, in 1891—my movie fudges the date—Westinghouse, fearing bankruptcy, persuaded Tesla to abandon his contract's $2.50-per-horsepower royalty clause for each manufactured Tesla motor, a source of future revenue for Tesla that would have amounted to millions of dollars. This is a central, abiding mystery in tracking Tesla's broken trajectory. Why didn't they negotiate a deferred or reduced rate? How did Tesla allow himself to be so fatally undermined? In one of the best recent Tesla tomes, *The Truth About Tesla: The Myth of the Lone Genius in the History of Innovation*, Christopher Cooper asserts Tesla "trusted that Westinghouse would bankroll all of his future endeavors after the industrialist reaped the financial windfall of Tesla's inventions. Of course, Westinghouse's largesse never really materialized." Cooper concludes: "This agreement with Westinghouse was far more responsible for Tesla's impoverishment than anything Edison ever did."

When Jim Gaffigan took on the role, we discussed how Westinghouse may have manipulated Tesla into this awkward transaction. It's possible, we agreed, to see Westinghouse as an amiable Santa figure who was capable of withholding some presents for himself. Gaffigan surmised it might be part of Westinghouse's shrewdness and charm to declare his vulnerability while behaving with overbearing insensitivity, seemingly oblivious to Tesla's

discomfort as he jostles him through a crowd, takes him into a side room, and draws their chairs close. Once Tesla selflessly tears up his contract, Westinghouse gives the inventor a big hug, exactly the last thing Tesla wants. It's one of the few displays of physical affection in the entire movie.

20 DEATH BY BEAM

*INVENTORS All die in the poorhouse. Somebody else
profits by their genius; it isn't fair.*
—Flaubert, *The Dictionary of Received Ideas*

Friday January 8, 1943. Tesla's *Times* obituary appears on page 19: "NIKOLA TESLA DIES; PROLIFIC INVENTOR"; with three subheadlines: "Alternating Power Current's Developer Found Dead in Hotel Suite Here" followed by "CLAIMED A 'DEATH BEAM'" followed by "He Insisted the invention Could Annihilate an Army of 1,000,000 at Once." A photo dated 1936—he would've have been 79 or 80—shows Tesla looking gaunt, beaky, but chipper, smiling directly into the camera.

I'd neglected to look this up until after the movie was finished but in January 2020, on the eve of our Sundance premiere, I wondered if the text might supply something quotable. It's an odd mini-bio, part character sketch. The uncredited journalist allows that Tesla "was greatly handicapped by lack of funds, for he was anything but a practical man as far as business was

The last known photograph of Nikola Tesla, undated. (Not the photo that appeared in the *Times* obit.)

concerned." This is followed by a curious bit of presumption: "Tesla probably could have become a rich man if he had chosen to become an employee of a large industrial concern, but he preferred poverty and freedom."

He certainly attained poverty, though Tesla also, on occasion, did submit to employment by larger concerns, most notably the Westinghouse Electric Corporation, though this affiliation goes unmentioned here, as do Tesla's well-documented intransigence and pride. The obit acknowledges that he was "one of the world's greatest electrical inventors and designers," and that his greatest inventions were developed in "the last twenty years of the past century." Tesla's systems for distributing and transmitting alternating current are singled out, and it's noted that his inventions for "electrical conversion and distribution by oscillatory discharges were highly significant, as were his researches and discoveries in radiations, material streams and emanations."

After the opening paragraphs, which lean into the human interest angle— "Dr. Tesla died as he had spent the last years of his life—alone"—the reader is supplied with seven full paragraphs detailing the death beam Tesla described in his declining years.

He'd first announced his high-velocity particle beam at a birthday press conference in 1934, upon turning 78, and he continued to disclose details year by year, a technological striptease. The beam involved four new inventions and was "based on an entirely new principle of physics that no one has even dreamed about." He was offering his services to the US Government and, as the world plunged into war, his elucidation became more specific. His beam "would be only one-hundred-millionth of a square centimeter in

diameter . . . and could be generated from a special plant that would cost no more than $2,000,000 and would take only three months to construct."

The *Times* fails to mention, as I noted in my script and film, that Tesla announced the invention "as a means to make warfare unthinkable." But, as the obit makes plain, warfare will always remain thinkable. It's remarkable how thoroughly the paper indulged the deceased inventor's theme; or is there more irony running through the reporting than I care to credit:

> The beam would melt any engine, whether Diesel or gasoline-driven, and would also ignite the explosives aboard. No possible defense against it could be devised, as it would be all-penetrating, he declared.

Then Tesla offered this caveat: "I would have to insist on one condition—I would not suffer interference from any experts. They would have to trust me."

Toggling to the front page, you can find the day's top headline announcing the President's State of the Union address: "ROOSEVELT SEES ALLIES ON THE ROAD TO VICTORY, URGES A POST-WAR AMERICA FREE FROM WANT." In times of war, of course, all news tilts towards or is shadowed by war. In any case, future generations to this day have harvested conspiracy theories from Tesla's death beam declaration, and a key part of his legend— reflected in yet another scene cut from my script—is invested in the FBI's emptying of the contents of the safe in his room, thousands of pages of private papers, which found their way to the Tesla Museum in Belgrade only decades later.

It's disquieting to consider the older Tesla, at once reclusive and craving attention, lured into discussions of his beam, holding forth on hygiene and dietary health—"I am convinced that within a century coffee, tea and tobacco will no longer be in vogue"—and voicing enthusiasm for eugenics "to prevent the breeding of the unfit by sterilization and the deliberate guidance of the mating instinct." This last line figures in an expansive 1935 interview conducted by George Sylvester Viereck, one of Tesla's firmer friends in later life, a German poet and journalist who permanently discredited himself by maintaining Nazi sympathies, landing in jail in 1941 when he was discovered accepting money to spread German propaganda in the US. Viereck's Tesla interviews, we might generously guess, involved a fair bit of ventriloquism.

My film wasn't quite finished when, at a cocktail reception at New York's Museum of Modern Art, I found myself in conversation with a grimly earnest older man at work on a documentary about Gorbachev. "Not the Herzog documentary," he explained. "This will be infinitely better." He was a massive, almost Wellesian figure in a three-piece suit, with a big-jowled boy's face. After he asked what I was working on, and I told him, he solemnly explained that the Pentagon has been developing Star Wars technology derived from Tesla's papers and prophesies. Tesla had been ahead of the game; we're only catching up with him now. Yes, I've heard that, I said, but do you really believe Tesla reinvented physics? Had he really been onto something practical, applicable and real? Oh yeah, the man assured me. He fixed me with a glassy-eyed stare. Without question.

21 AN EMPTY CHAIR

We are all interested in the future, for that is where you
and I are going to spend the rest of our lives.
—The Amazing Criswell in *Plan 9 from Outer Space* (1957)

There are a few occasions in the movie—I had originally imagined more—
where empty chairs figure in the story with some unspoken significance,
standing alone or stacked among others or, in one freighted moment,
awaiting the arrival of a man whose life will end in the chair because it's been
wired to an alternating current generator. Chairs are mundane, manmade
objects that can signal, or channel, higher power. The electric chair is, of
course, a kind of throne. We set chairs out, intending to sit in them or see

Tom Farrell as Warden Charles Durston behind Blake DeLong as William Kemmler in *Tesla*.

them occupied, but their emptiness can fill them with an alternate identity and purpose. God, according to a college lecture I half recall, is depicted in Indian Mughal painting as an empty chair. In early Buddhist art the blessed one never appears in human form; Buddha's presence is rendered through footprints or, more often, an empty chair. Divine presence is physicalized as a hovering absence. "Emptiness best represents the unknowable, ungraspable field of being and nothingness that is the foundation of Buddhist teaching. In this way, the empty chair can be said to be a symbol of our truest nature."

Reading and remembering this brings me up short. I wasn't aiming to be quite so literal-minded when I littered the film with empty chairs. I was chasing an intuition about openness, latency, immanence. And when I chose to place an empty chair in the film's final frame, it was meant as a nod to Tesla's lifelong wish to make himself available to the unknown, rather than, strictly speaking, his pursuit of the unknowable. In some respects, he was as patient and persistent as a fisherman casting a lure, then casting again. "In Bali," my random research informs me, "to stand in front of an empty chair is to reckon with everything you do not know and yet strive to understand." I thought of the chair at the movie's end as an emblem of reckoning and striving, a surrogate for us all, facing a threshold conscious thought can never cross.

This, anyhow, was the rough idea.

Edouard Manet, "The Shadow that Lies Floating on the Floor," lithograph illustration for Poe's "The Raven," 1875.

22 ENDPOINT

Were there pigeons in Tesla's room when he died? Room 3327 on the 33rd floor—room and floor designations divisible by three, Tesla's determined adherence to his lifelong fascination with the number. In the script I described bird cages lining the window sills and Tesla's body "fully clothed, evenly laid out on the bed, the face pale and rigid in profile as if cut from metal." That's from the first draft; the image carried over into the final shooting script, though the scene was peremptorily cut when we started calculating how much it would cost to build or even simply dress a 1940s hotel suite and to install in it an elderly Ethan Hawke look-alike or maybe Ethan Hawke himself, prosthetically wizened. It was a relief, as well as a disappointment, to sidestep this dismal endpoint.

No. 167

NEW YORK,

J. P. MORGAN &

BANKERS,

Nikola Tesla

23 BEYOND THE MIRROR WORLD

I haven't been in the mood to read my reviews. Cowardice, frayed nerves, or an instinct for self-preservation—your guess is as good as mine. Publicists forward them in clumps and I catch sight of titles, scan paragraphs, reading through my fingers. But I know in advance, taking in this parade of plot summaries and opinions can feel like plunging into Mandrake's Mirror World, the alternate reality where virtues and vices are flipped, your best intentions are travestied or rendered invisible, your worst self is reflected back at you like a grotesque cartoon.

Meanwhile a filmmaker friend named Jae Song—a friend of a departed friend, actually; we're bound by a shared sense of loss—sent an email out of the blue, writing to say *Tesla* was the first movie he'd watched "since lockdown." His praise was subsumed by a flow of elliptical personal musing, all the more disarming for seeming composed of fragments from unfinished haikus:

> *Felt for her and him . . . makes me wonder about . . . settling . . . about being vindicated or being loved . . . about creation and "failure" of the creation . . . and the very end of the movie . . . the moments of children in the film . . . future . . .*

When I responded—no one, I told him, had noticed or asked about the children in the film—he wrote back more fully:

Tallulah McCrae Silovsky and (reflected) Ethan Hawke and Jim Gaffigan in *Tesla*.

Funny—to me it was almost all about the children. The first story we hear is about Edison's childhood. The trauma that perhaps made him who he is or at least we see his character through it. Then Tesla's childhood trauma . . .

The little interjections of children throughout—the adults only caring about themselves and the now . . .

I feel like the movie was saying T wants to stop the traumas of childhood in the world. While E and JP react to their traumas in almost anger—disown their childhood . . .

I feel like T's attraction to Sarah has to do with the way she was a child—she can navigate the adult world and be successful and adored and not grow up.

They are both children. T has never grown up.

What does growing up mean? Is innocence idealism? I don't know . . .

And the collage aesthetic of the film goes with the idea of children, play. Like a child telling a story—or someone excited to tell a story that may forget a detail and go back or add a detail . . .

Mandrake enters the Mirror World. Daily comic strip written by Lee Falk, drawn by Phil Davis, November 25, 1944.

Of course, making these unwieldy things, feature-length movies, you set out with a basic aim to reach an audience, people gathered in the dark, ideally, watching other people projected on a screen, larger than life, generating a circuit of emotion that flows into a collective reservoir of intimate experience. It doesn't feel mystical to suggest this circuit is central to the medium: passage into a tangible Mirror World, seductive, treacherous, but ultimately enriching. To gather resources and put a movie together aiming for anything less would be like manufacturing a lamp without expecting it to give off light.

Maybe I've crossed a threshold, carrying this impossible film on my back for years, aided by a few loyal and unlikely accomplices, so I can almost consider myself content, just now, marveling at the fact that the movie exists at all. Its release in the Unites States, at a time of circumambient turmoil, included screens in over a hundred theaters, venues whose names remind you that the country is not all one place: the Wildhorse Resort and Casino in Pendleton, OR, the Myrna Loy Center in Helena, MT, the Princess Theatre in Lexington, TN, the Doric Theatre in Wichita, KS, the Chagrin Cinema in Chagrin Falls, OH. Few if any of my movies have been so widely distributed. This nominal achievement is overshadowed by the grim caveat that the farflung audiences were sparse, distantly spaced, wearing masks. An image that might have been imported from one of Mandrake's darker episodes.

24 POSTER CHILD

Our Japanese poster arrived, an imaginative design—rapturous, solemn, silly
—applying an image of Ethan's Tesla as he never appeared in the film,
disheveled hair hanging loose off his forehead, with a photoshopped hand
held close to his face, a miniature tree of white lightning filling the space
between forefinger and thumb. I conveyed my congratulations to the
distributor while inwardly noting that this poster was promoting a movie
I hadn't delivered. I might have made that movie, I told myself, if I'd been
struck by lightning and/or possessed by the mad ghost of Ken Russell.

Poster designed by Kengo Tobita, courtesy of Hakuhodo DY Music & Pictures, 2020.

世界は100年遅れていた—。

彼がいなければ

イーサン・ホーク

テスラ
Tesla

エジソンが恐れた天才

While contemplating this more daring, delirious, insolent, sordid and sexy Tesla biopic, and my failure to come up with it, I note, in the new poster, how the mini-lightning in Tesla's hand echoes the jagged line between Ethan's eyes, which jogs my memory of a photograph that's haunted me since I chanced on it decades ago, a portrait of a man identified by a clarifying caption: "Chukcha hunter, survivor of bear attack, Vrangel island, USSR, 1936."

The postcard providing this information gets the photographer's name right: Dmitry Debabov, responsible for famous heroic images of young Sergei Eisenstein and Vsevolod Pudovkin; but *Chukchi* is the current, accurate designation for the hunter's lineage and language. "According to recent genomic research," Wikipedia tells us, "the Chukchi are the closest Asiatic relatives of the indigenous peoples of the Americas."

The hunter's open smile, working around his white pipe, radiates confidence and good cheer, equally evident in his misaligned eyes. The picture is a reminder—or is this just the lesson I've chosen to extract from it?—that most people have withstood damage, visible and invisible hardship, and even survived being torn in two, yet it's possible to accept our reassembled selves and each other with various degrees of candor and hope, each of us holding onto a private dispensation of survivor's luck— while it lasts.

For years I've wanted to know more about this anonymous, indestructible role model. His story, pre-and post-attack—that's a biopic I'd dearly like to see.

Portrait of a Chukchi hunter by Dmitry Debabov, 1936.

9 I want! I want!

25 UNFINISHED PROJECTS

Diodorus Siculus tells the story of a god who had been cut into pieces and then scattered; which of us, strolling at dusk or recollecting a day from the past, has never felt that something of infinite importance has been lost?
—Jorge Luis Borges, *Paradiso XXXI, 108*

Let the beauty we love be what we do.
There are hundreds of ways to kiss the ground.
—Rumi

After *Tesla*'s second Sundance screening, on a Tuesday morning, January 28, 2020, I was followed out into the parking lot by an Asian man with close-cropped hair. He was wearing a curious onesie pajama outfit, and he waited for me to finish talking to someone else, then introduced himself, speaking in a flat-voiced torrent, explaining that he had sold his company to Amazon

William Blake, a plate from *For Children: The Gates of Paradise*, 1793.

for $1 billion in 2009 and was now living in Las Vegas where he'd like me to visit because he was interested in fulfilling some of Tesla's unrealized ideas, bringing those unfinished projects to life. I remember looking at him more closely than I was listening. His smile was childlike, impish, and his eyes had a bright, patient, unblinking quality. I sensed he had speed-talked through his self-introduction hundreds of times before. The presence of two men at his side, assistants of some kind, monitoring the situation, it seemed, with contained excitement, added to the absurdity of his request. I gave him my phone number while trying to disabuse him of the notion there was a true possibility of picking up where Tesla had left off. He texted me to arrange a meeting, following a text from one of his associates; I texted back the next day, apologizing for not responding sooner, and a phone call was set, because by then they'd flown back to Nevada.

I was pacing in the sunlit snow, days later, listening to him explain himself more thoroughly—describing the community he'd established in downtown Vegas, the spirit of idealism, experimentation and fun informing his ongoing plans. Fun, I appreciated, was a key word. By then I'd Googled him—Tony Hsieh, still CEO of Zappos at that time, the visionary entrepreneur, a master shoe salesman who didn't care about shoes, author of the book *Delivering Happiness*, and so on ...

I'm finishing this memory-splintered book as details continue to emerge about Hsieh's sad last days. The invitation I accepted—to "stay with us at our tiny house/airstream village, and chat about ideas around the fire"— dissolved without my noticing it when the pandemic broke out. I hadn't checked back or even thought of Tony Hsieh in all these months, until reports

Frank Paul's cover painting for *Science Wonder Stories*, October 1929, inspired by Tesla's description of his unrealized "thought recorder."

Science WONDER Stories

October

25 CENTS
Canada 30c

HUGO GERNSBACK Editor

of his death became front-page news. It's unsettling, now, to imagine chatting around the fire with a man who, recent reports inform us, became obsessed with fire, who died from complications of smoke inhalation after apparently barricading himself in a shed adjoining a house that caught fire around 3 am, November 27, 2020. The *Wall Street Journal* reports that Hsieh, earlier in the year, impulsively bought a mansion for about $16 million and filled it with a thousand candles, because, the real estate agent said, "Mr. Hsieh 'explained to me that the candles were a symbol of what life was like in a simpler time.'"

The *Journal* and other sources have documented Hsieh's compulsive rush, in the last months of his life, towards a kind of purification, a self-winnowing program that included a "digital detox," giving up his laptop and phone, and "biohacking," testing his body's ability to reduce his need for sleep, food, and oxygen—without, however, limiting an intake of alcohol, mushrooms, ecstasy, and nitrous oxide.

Among the many valedictory tributes, there are compelling accounts of Hsieh's generosity, his creative and sincerely sweet-natured approach to management, his remarkably effective efforts to challenge hierarchies in corporate culture, attempting to erase the divisions Elon Musk breezily tweeted about.

He'd resigned from Zappos in August, seemed to know he was spinning out of control, had agreed to enter a rehab facility in Hawaii. He was a month away from turning forty-seven. His estate is valued at $850 million. He did not leave a will.

While gleaning these dramatic and confounding facts from various reports, I happened to be revisiting Jean Cocteau's *The Difficulty of Being*, an essay collection with this quip carried in the introduction:

> If your house were burning down and you could take away one thing, what would it be? "I'd take the fire," answered Jean Cocteau.

"Taking the fire" overrides the standard investment in mere matter, blunt objects, money, the material world, if you happen to be aiming for a simplified, transcendental existence. That said, there's no comfort in relating Tony Hsieh's self-mortifying downward spiral with Nikola Tesla's slower final descent.

I'm left to wonder what Hsieh saw in my movie, which he said he and his team loved. Might he have recognized himself in Tesla's creativity, his ambition, or his social awkwardness—or did he appreciate the implication, in the portraits of other players, that the pressures of success can rival the dissatisfactions of failure? Our deferred conversation, if it had eventually taken place, might have scraped against the edges of Hsieh's secretly gathering despair, but it probably would have been more of a group hang, akin to the "wacky" Burning Man exploits he described on the phone—fun to keep the non-fun at bay.

During the Q&A following the film's third and last Park City screening, I startled myself by choking back tears, being unable to speak for several seconds, when someone asked why the film is dedicated to Sam Shepard.

Running the promotional treadmill that week, I was all too aware of various ghosts at my back and mirages up ahead, while contending with the mind-numbing suspense radiating from the question of how or if a distributor might take on my movie. More simply: I felt exhausted and decentered, as if I'd staggered to the crest of a steep unpaved road and a dense fog had rolled in, swallowing the view. I was told, at that morning's screening, that Bill Gates was in the audience, and he was pointed out to me—in a plaid shirt and glasses, looking agreeably owlish, just like in his photographs—before I introduced the film. I asked how many people in the theater knew something about Tesla, the man rather than the car, and Bill Gates raised his hand, along with about a third of the crowd.

According to a friend sitting directly behind him, Gates watched with attention, and laughed a few times, notably when Tesla tells Anne Morgan "I would like a coffin." He stayed through the Q&A. He did not follow me out into the parking lot.

Tesla experimented with X-rays before they were known as such, in 1896, producing sharp clear "shadowgraphs" soon after Röntgen announced his discovery of the hitherto unknown rays; but health hazards soon became apparent, Tesla didn't arrive at a commercial utility for this work, and his pioneering (and potentially lucrative) research was set aside in favor of his fascination with wireless energy.

In March of 1895, a fire burned Tesla's South Fifth Avenue laboratory to the ground, devouring irreplaceable equipment, models and papers, years of

Tesla's X-rayed hand, 1895. A "shadowgraph" made using vacuum tubes of Tesla's construction.

work. One of the only scenes I shot and cut from the film referred to this fire without showing it. As Tesla hadn't been in the lab at the time of its destruction, the scene raised questions that would've dangled distractedly if retained.

Uninsured, and stunned by the loss, Tesla accepted an invitation from Edison and transplanted himself for a few weeks in his arch rival's workshop in Llewellyn Park, New Jersey. Tesla staved off insolvency and depression, set up a new lab in Manhattan, pressed on. In 1896, the next year, the inventor posed for one of his most iconic portraits (see page 107) and dined with Sarah Bernhardt and Vivekananda, trading opinions about eternity and the afterlife. (In reporting the event, the *New York Herald* identified Tesla, simply, as "one of the inventors of photographing through opaque substances.")

A later, more tenuous unrealized project—anachronistically alluded to in my movie, in the tennis scene—is a machine for photographing thought. Tesla's "thought recorder," announced when he was in his seventies, involved transcribing mental images off the retina and playing them back like a slideshow. Neuroscience has yet to catch up to the concept, though there have been a few movies proposing this technology within a set of eye/brain/camera/screen interfaces. Vide: Bertrand Tavernier's *Death Watch* (1980), Wim Wenders's *Until the End of the World* (1991), and Kathryn Bigelow's *Strange Days* (1995). Of course, the nature of consciousness, of memory and, for that matter, of madness, is mirrored and mocked by our dreams, in our dreams, and this thread of late twentieth century sci-fi films is hardly unique in indicating how movies contain oneiric currents and depths, exposing suppressed emotions and desires. "A dream that escaped from sleep"—

Cocteau's description of a film he liked—can apply to most of my favorite films.

By way of a farewell, as a catastrophic, grief-stricken year draws to a close, at a time when theatergoing has been outlawed and the future of independent filmmaking appears particularly fragile, I offer up another postcard—a portal into a more innocent era. It just turned up, during yet another bout of pandemic-motivated decluttering.

I'd bought it in Lyon, France in the gift shop for the Musèe Lumière, the preserved family villa where the Lumière Brothers grew up, now occupied by glassed and boxed displays of image-making and image-sharing devices, machines and furniture contemporary with the devising of the Lumières' cinematograph, the first workable, practical, successful motion picture technology, conjured at a time when this technology was akin to magic.

I bought the card without realizing the young men in the photo are the brothers themselves, mere boys, in fact, thirteen and fifteen years old, decades before they became plump, mustached, adult engineers, industrialists, "illusionists" and, most definitively, the accredited dual fathers presiding over the birth of cinema.

Louis, the younger, is slumped over the table, eyes closed, as if having fallen asleep in front of the open book; Auguste reaches for his brother through the adjacent window, his hand poised to touch his head, to wake him up. Who directed this tableau? Why does it seem so poignant to imagine the pretended sleeper interrupted from a dream? The photo both anticipates and

elides the boys' unlived futures, as do all childhood photos, but to my mind it's especially moving to catch sight of these brothers enacting this charade, a prelude to the visual storytelling unleashed by their invention, a medium affecting generations of lives rippling outward from their own. It's easy to circle back to Cocteau. "Art," he wrote, "is a shared dream." And: "The artist does not describe his dream; he shares his dream in public."

You'll notice I've ladled a fair amount of description into this book, as if to admit, in the cold clear light of day, that I haven't dreamed my Tesla movie as deeply or fully, as vividly or viscerally, as spellbindingly as I would have liked. I tried looking Nikola Tesla in the eye and, as in Paul Auster's novel, he glanced back and stared right through me, leaving behind an ashy residue, a taste of mortality, an invigorating sense of my own nothingness. Yes, there's a film, an array of reviews, a couple nifty posters. But in my mind—it should have been obvious, but I'm just realizing it—the project will always be unfinished.

Louis and Auguste Lumière in Lyon, France, 1877.

ACKNOWLEDGEMENTS

I'm grateful to Colin Robinson for believing I might have something further to say about Nikola Tesla, and for extending the invitation to write this book even as reality lurched and supplied good reason to drop the idea altogether.

Although not directly cited here, Mark J. Seifer's suitably obsessive, seminal *Wizard: The Life and Times of Nikola Tesla, Biography of a Genius* (Citadel Press, 1998) has been vital in grounding and expanding my understanding of Tesla's life and work. W. Bernard Karlson's *Tesla: Inventor of the Electrical Age* (Princeton University Press, 2014), mentioned earlier, is comparatively cool-headed, equally compelling and instructive. Despite their deceptively frothy titles, Nigel Cawthorne's *Tesla: the Life and Times of an Electric Messiah* and *Tesla vs. Edison: The Life-Long Feud that Electrified the World* (both from Chartwell Books, 2014 and 2016 respectively) are filled with astute observations and smartly organized excerpts from out-of-the-way sources.

I double down on recommending Christopher Cooper's *The Truth about Tesla*, referenced earlier, an antidote for over-circulated misconceptions and fantasies, though I also enthusiastically endorse the high level of myth and mystery pulsing through Vladimir Pistalo's kaleidoscopic novel, *Tesla, a Portrait with Masks* (Graywolf Press, 2008).

Doron Weber and the Alfred P. Sloan Foundation provided profound institutional support for the movie underlying this book, including grants and awards that involved partnerships with SFFilm and the Sundance Institute. I am abidingly grateful.

It also gives me pleasure to thank Avi Lerner and the team headed by Jeffrey Greenstein at Millennium Media for their commitment and support throughout the making of the movie.

A salute of deep gratitude is also due Arianna Bocco and her colleagues at IFC Films for launching *Tesla* in the U.S. with such sweeping energy and confidence.

Though they go unmentioned in the preceding pages, I want to acknowledge the invaluable contributions of Kathryn Schubert, the film's meticulous, patient and speedy editor, and Per Melita, the tough but tender producer who was most deeply planted in the trenches as principal photography was underway.

Many other collaborators would rate detailed praise in a more straight-forward "making-of" account of the movie; I'm sorry my scattershot approach doesn't grant them due credit or name more of the essential friends and team players who shaped the film before, during and after the shoot, and eased its passage into the world. The least I can do is to thank them in passing, bluntly and alphabetically:

Marc Alessi, Jameal Ali, Danny April, Dan Bitner, Joan Bostwick, Lucy Bright, Hilary Brougher, Linda Brown, Bingham Bryant, Christa Campbell, Kris Casavant, Ellen Athina Catsikeas, Eddie Collyns, Jivko Chakarov, Meghan Currier, Dominic Davis, Jim Dobson, Steve Erickson, Naomi Foner, Bears Rebecca Fonté, Josh Friedman, Renée Frigo, Rivka Galchen, Lawrence Garcia, Karl Geary, Emory Gleeson, Javier Gonzales, Trish Gray, Peter Green,

Heather Greenstein, Paul Grimstad, Hannah Gross, Stephen Gurewitz, A. S. Hamrah, Mark Harelik, Ryan Hawke, Bethany Haynes, Hermione Heckrich, Billy Hopkins, Caitlin Hughes, Ashley Ingram, Gideon Jacobs, David Kallaway, Matias Kalwill, Spencer Kayden, Bart Keller, Adam Kersh, Lewis Klahr, Piibe Kolka, Christos Konstantakopoulos, Jonathan Lethem, Peter Levine, Rick Linklater, Ian Lithgow, David Lowery, David Mackenzie, Alison Maclean, Michael Mastro, Jesse Moss, Emma Myers, Ethan Nelson, Nick Newman, John Paesano, John Palladino, Tricia Peck, Haley Pehrson, Mike Plante, Jonathan Podwil, Randy Poster, Kelly Reichardt, Sarah Resnick, Vadim Rizov, Paul Risker, Isen Robbins, Tom Roma, David Rooney, Eli Roth, David Schiff, Christian Schneider, David Seltzer, John Sloss, Eli Smith, Steven Soderbergh, Jae Song, Jerry Stein, Jean Strouse. Ryan Svendsen, Bayley Sweitzer, Scout Tafoya, Amy Taubin, Steven Thomas, James Urbaniak, Caroline von Kuhn, Lucy Walters, Rick Zahn. Thank you all for variously pitching in, showing up, and coming through.

For the delivery of this book into its near-final form, I'm particularly indebted to Robert Walsh for his comprehensive editorial attention and advice. Eliot Larson, the book's designer, accommodated the shifting landscape of the layout with remarkably sustained patience and skill. Emma Ingrisani attended to formidable challenges involving the illustrations while keeping the wheels of production on track. For reading and commenting on various versions of the manuscript, deep thanks to Andrei Codrescu, Jessica Holburn, Jim Jarmusch, Susan Kismaric, Aja Nisenson, Jim Robison, Jonathan Rosenbaum, Courtney Stephens, and Stephanie Zacharek.

Tesla in his office in the Woolworth Building, New York, circa 1916, the year his autobiography, *My Inventions*, was first published.

PERMISSIONS

Cover and Frontispiece: Image accompanying article "The Problem of Increasing Human Energy," Nikola Tesla, *The Century Magazine*, The Century Co., New York, June 1900. Image via Alamy.

xxiii "Nikola Tesla," Herbert Rose Barraud, photograph, 1896. Accessed via Wikimedia Commons.

viii "Nikola Tesla," Marius de Zayas, charcoal over graphite on paper, 1908. National Portrait Gallery, Smithsonian Institution. © Estate of Marius De Zayas.

xxvii "Engraving of Serbian-American inventor Nikola Tesla (1856–1943) lecturing before the French Physical Society and The International Society of Electricians, circa 1885." Kean Collection/Getty Images.

4 "Peter Harrison Asleep," John Singer Sargent, watercolor on paper, 1905. Artefact/Alamy Stock Photo.

6 Photography by Davis & Sanford, New York, of Pierpont Morgan's daughters, Louisa, Anne and Juliet Morgan, circa 1900, recto. Courtesy the Morgan Library & Museum.

10 Anne Morgan, 1907, courtesy Art Resource.

19 Self-portrait, Alex Toth, mid-1970s. © Alex Toth. Used with permission. bydana29@yahoo.com.

21 Panel from *Scorchy Smith*, Noel Sickles, 1936. From *Scorchy Smith and the Art of Noel Sickles*, copyright and courtesy the Library of American Comics LLC.

23 "The Last Thing (Das Letzte)," Käthe Kollwitz, woodcut on paper, 1924. Reproduced with permission from the Artists Rights Society.

26 James Joyce, 1925, Science History Images/Alamy Stock Photo.

30 Cover image, *The Official Mandrake, Issue #1*, 1989, Lee Falk and Phil Davis. Mandrake the Magician © 2021 King Features Syndicate, Inc.

34 Panel from *The Phantom*, Lee Falk, 1936. © 1939 King Features Syndicate, Inc.

44 Cover of *Tesla*, #0, Red Giant, 2014. © Red Giant Entertainment.

51 "Samuel Clemens and John T. Lewis (an elderly African American man), both full length, seated on steps of porch," T.E. Marr, black and white film copy negative, 1903. Library of Congress Prints and Photographs Division Washington, D.C.

54 "Orson Welles as Faust rehearses with Eartha Kitt as Helen of Troy at the theatre in Paris on June 14, 1950." AP Photo/Jean Aubry.

56 "Night Stroll," Georges Seurat, 1887–88. Collection of Von der Heydt-Museum, Wuppertal, Germany.

59 Orson Welles collage frontispiece from *Premier Plan Hommes Oeuvres Problemes du Cinema No 16: Orson Welles*, 1961.

67 Thomas Edison, 1893, courtesy Getty Images.

75 Édouard Manet, illustration from "Le Corbeau = The Raven : poëme / par Edgar Poe ; traduction française de Stéphane Mallarmé ; avec illustrations par Édouard Manet," 1875. Lessing J. Rosenwald Collection, Library of Congress.

83 Poster for *Cherry 2000*, 1987, Orion Pictures.

88 Sarah Bernhardt in *Theodora*, 1884, photo courtesy Getty Images.

92 Swami Vivekananda photograph, 1900, courtesy Ramakrishna Vedanta Society.

111 "At the Milliner's," Edgar Degas, pastel on paper, 1882. H. O. Havemeyer Collection, Bequest of Mrs. H. O. Havemeyer, 1929, Metropolitan Museum of Art.

115 "Edison's greatest marvel--The Vitascope," color lithograph, 1896. Library of Congress Prints and Photographs Division, Washington, D.C.

120 Petar Bõzović in a still from *The Secret of Nikola Tesla*, 1980, courtesy Zagreb Film.

126 Publicity still, *The Prestige*, 2006, courtesy Warner Bros/Touchstone Pictures.

129 Illustration of Nikola Tesla accompanying article "Our Foremost Electrician," Arthur Brisbane, *New York World*, July 22, 1894.

131 Tesla demonstration image accompanying article "The Problem of Increasing Human Energy," Nikola Tesla, *The Century Magazine*, The Century Co., New York, June 1900.

134 J. P. Morgan photographed by Edward Steichen, 1903. © 2022 The Estate of Edward Steichen / Artists Rights Society (ARS), New York.

137 Orson Welles, 1966, Georges Galmiche\INA via Getty Images.

58 "Nikola Tesla (1856-1943), Serbian-American physicist sitting in his Colorado Springs laboratory with his "Magnifying transmitter" - 1899 (Multiple exposure)." Photo by Stefano Bianchetti/Corbis via Getty Images.

163 "Suit of Nikola Tesla in Nikola Tesla Museum, Belgrade, Serbia," © Katarina Stefanovi, user Katarina 2353, Flickr.com.

175 "Elsa Lanchester And Boris Karloff in 'Bride Of Frankenstein,'" 1935. Photo by Universal/ Getty Images.

193 Édouard Manet, illustration from "Le Corbeau = The Raven : poëme / par Edgar Poe ; traduction française de Stéphane Mallarmé ; avec illustrations par Édouard Manet," 1875. Lessing J. Rosenwald Collection, Library of Congress.

205 Chukcha Hunter, survivor of bear attack, Vrangel Island, U.S.S.R. 1936. Photo by Dmitry Debaboy for Sputnik.

199 Mandrake the Magician © 1944 King Features Syndicate, Inc.

206 William Blake, *For Children. The Gates of Paradise*, Plate 11, "I want! I want!" Etching and line engraving, 1793. Yale Center for British Art, Paul Mellon Collection.

All stills from *Tesla*, 2020, courtesy of Nikola Productions, Inc.

Michael Almereyda in New York, circa 1980. Photograph by Tom Jenkins.

Michael Almereyda has written and directed fourteen feature films, most recently *Cymbeline, Experimenter, Marjorie Prime, Escapes,* and *Tesla.* He has edited and contributed essays for books on Vladimir Mayakovsky, William Eggleston, Manny Farber, and Garry Winogrand.